"*From the Circle* is Richard Heller's highly original, fascinating collection of stories, poems and images. Authentic and inspiring, the book resonates with Heller's devotion to creating meaning from his life experiences.

Readers are fortunate to have such an insightful, honest, wonderfully entertaining guide through those experiences. *From the Circle* is a book to return to again and again."

— Holly Prado, Author
Oh, Salt/Oh, Desiring Hand,
Cahuenga Press, 2016

"This book is dangerous. Do you remember what it was like to be frail, vulnerable, and innocently invincible? Can you recall looking straight into the eyes of the dazzling earth into which you were roughly thrown at your birth? Are you willing to recover the world you delighted in before the four walls constricted your fluid body and your unfettered vision?

The present collection of mixed media pleadingly calls the reader back to who you were in the first decade of life. Perhaps the greatest praise for Heller's work comes from the dogs who growled at his wolf sculpture. It is impossible to have a neutral response to the stories, poetry, and photographs whose wildness is barely held together by the binding. In consuming these pages I found myself alternately growling like the dogs and wanting to nudge my head into the author's chest like the horse, Duffy. Allow the author to stoke his forge and set your heart on fire."

— Br. Scott Whittaker

"Hephaestus, the spirit of fire, of sculptors, artisans, and blacksmiths, informs Richard Heller's *From the Circle*. Like Hephaestus, Heller is a magic maker. He "loosens the light" in his writing and his sculptures. He pours the light into his home and all things he makes: gates, a fire screen, towel racks, even hinges. Along with pen and computer, his tools are forges and welders, anvils and fire. He fashions the light into a raven, Sitting Bull, a wolf. He turns it into poems, stories, a novel. For forty years he hammered the light into shoes for horses in his long career as a farrier. All these are parts of the circle that is Heller's life.

The book is also a love story, chronicling his love for horses and dogs, his wife, Lyra, and their son, Daniel. His son grabbed his finger after he was born, and Heller "was lost, forever…Love had swallowed (his) heart."

This is a book that charts the author's relationship with people and animals, and his relationship with craft. It is a story of hooves, of fire, of travel, and of an extraordinary life lived with honesty, passion and humility."

— Phoebe MacAdams, Author
The Large Economy of the Beautiful: New and Selected Poems
Cahuenga Press, 2013

FROM THE
CIRCLE

to Elliot,
my there always Be a
Song in your Heart!

[signature]

FROM THE
CIRCLE

POETRY • PROSE • ART

RICHARD
HELLER

Written works previously published in:
Arabian Spirit, by Doreen Haggard
Blueprints, by Richard Heller

Cover Design by Shiloh Schroeder, Fusion Creative Works; fusioncw.com.

Cover: Sculpture *Sitting Bull* by Richard Heller. Photo by Scott Hensel.

Book Interior Design by Cheryl Feeney.

Published by Plicata Press LLC

Soft Cover ISBN: 978-0-9903102-8-0
Hard Cover ISBN: 978-0-9903102-9-7
Library of Congress Control Number: 2018962197

Publisher's Cataloging-In-Publication Data
(Prepared by The Donohue Group, Inc.)

Names: Heller, Richard, 1952- author.

Title: *From the Circle: Poetry, Prose, Art* / Richard Heller.

Description: [Gig Harbor, Washington] : Plicata Press LLC, [2018] | "Written works previously published in: *Arabian Spirit,* by Doreen Haggard [and] *Blueprints,* by Richard Heller."

Identifiers: ISBN 9780990310280 (softcover) | ISBN 9780990310297 (hardcover)

Subjects: LCSH: Heller, Richard, 1952- | Sculpture. | Blacksmithing. | Horsemanship. | Horseshoeing. | LCGFT: Poetry. | Essays. | Pictures.

Classification: LCC PS3608.E455 Z46 2018 | DDC 818/.6--dc23

In remembrance of Holly Prado Northup

Contents

Witness

I Have to Sit 3

Almost Three in the Morning 4

Lost Wax Process 5

Patina 8

Torso 10

You Think We Should All Calm Down 12

Rwandan 13

Prisoner 19

Red Rock Canyon 29

It's A Dark That Sunlight Can't Penetrate 30

The Illusion Is We Don't Know 31

Everything Else Broken 32

Earth's Changes 33

Vision 34

Aria 35

Speak

If We Didn't Have Words 39

Truth and Beauty 40

Beach 41

Dr. Joe, 42

Wallace 43

My Life 47

Punctuating Time 49

Words Leading Me Home 59

An Embrace That Lasts Longer Than Fear 60

Mother's Sun 61

Dyl-Le-En 62

To You, Lyra 63

Sitting Bull 67

Done 73

The Great Divide 81

School Days 83

Snap Back at Rudyard Kipling's IF 85

The Reading 87

Love It Wasn't 93

My Shyness 94

When I Wasn't Shy 95

When Words Were My Servants 96

See Life This way 97

Alba 98

Santana's Raul and Karl Drum Africa in Tacoma 99

Other World

Step Running 103

Clink and Luka 105

Fangs Woo Passion 113

Remembering Them 115

Innoncence Lost 124

Thief 127

Grizzly Bears 129

Vulture 132

Crooked Horns 133

Snake Killer 136

Whisky 139

My Horse 142

Caleyndar 145

Duffy 151

Both Worlds

Too Late to Draw Back 167

If I Tend Myself 168

If Only 169

Method of Disorder 170

The Fourth Season: 2016 173

Whole

The Blue Marble 186

It's My 62nd Year 187

Evening 188

Sculptures

Bear 131

Crooked Horns 134, 135

Done 70, 77, 78, 79

Dyl-Le-En 9

Herzegovina Woman 15

Man 16, 17

Martha 123

Raven 125

Rwandan 14

Sitting Bull Cover, Preface, 68, 69

Snake Killer 137

Strength 65

Torso 11

Whisky 141

William Wallace 44, 45

Wolf Looking In Tree 120, 121

Wolf Mask 114, 119

Wolves Fighting 112

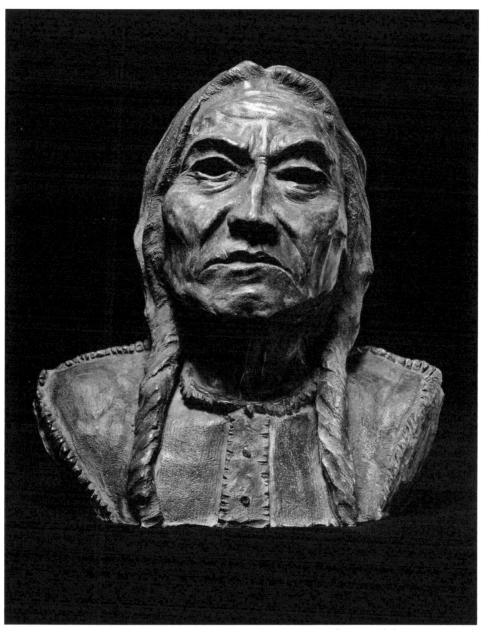

Tatanka Iyotake (Sitting Bull)
Bronze

Preface

The Tatanka Oyate (Buffalo People) believe we all have a place in The Circle, and the entirety of our perceptions will be formed by our vantage point within this circle.

By way of sculpture, short stories, prose, and poetry, I attempt to share what I see. I hope the reader will find this book to be at times raw, other times loving or humorous, and always honest.

It's an honesty that on occasions has kept my work from being shown: A sculpture of a wolf was commissioned for a veterinarian's office. When it was installed, the doctor was pleased, but many of his dog patients cowered or growled. It was soon removed. Within the Native American community, my sculpture of Tatanka Iyotake (Sitting Bull) has received favor, while the director of a European-American-produced Western art show wrote, "The main comments from the jurors were that they liked the bear and cowboy pieces you submitted, but found the Native American bust to be dark and somewhat frightening."

From the Circle is an accounting of how I become reflective and see my connection to everything.

Acknowledgments

To Eda Martinek-Jensen, sculpting mentor who taught me to be an artist, not a student.

With deep gratitude to the writers in my Los Angeles writer's workshop: Phoebe Ozuna, Margaret Walsh, Kathleen Tyler, Jen McCreary, Brenda Miller, Sandra E. Cohen, Joan Isaacson, Bill Banks, Vicki Mizel, Marie Pal-Brown, Kathleen Bevacqua, Gina Battaglia, Garrett Brown, Marlene Saile, Jason Greenwald, Linda Ruggeri, Fernando Castro, Doko Sharrin, Sharon Melina Rosner—their patience and guidance were critical in making this book something I am proud of.

And to my Gig Harbor writing compatriots, Jan Walker, Cheryl Ferguson Feeney, and DL Fowler—their constant encouragement and caring criticisms kept me going.

I am grateful for the friendships of Mark Sheppard, Brent McEwan, Tim Cooper, Marla K. Riviera, Tom Hamilton, Ron Sharrin, Lerae Leaver, Frosty Horton, Tom and Ann Gallon, Esta Bernstein, Beth Rosen, Gregg and Cathy Pittman, Garret Davis, Jim and Julie Visner, Chris Allport, Jay Storer, Betty Mott, Kristen and Eric Yang, Lawrence Casperson, Michael Covert, Lisa Casperson, Sarah Oberpriller, Carol Walker, Johnny Gonzales, Sherry Stevens, Adrienne Fayne, Lee Serrie, Sara Greenspan, Michael Norman, Charlotte Bornstein, Savannah Finch, Aura Kuperberg, Zoreh Gottfurcht, Timothy Acker, Don Havens, Gary Glasgow, Ron Walsh, Robin Foster, Timothy Mansen, Joe Lamb, Tammy Radford, Craig Radford, Sweet Pea, Nick Finney, Abigail Reed, Annmarie Huppert, Becky Cooper, Mark Duhamel, Terry O'Brian, Linda Jacqueline Reboh, and Reggie Shelton.

Special thanks to editor Cheryl Ferguson Feeney, who cared as much as I did about getting it right, for her fearless belief in the creative process. She was a mentor from first draft to publication.

Two Ravens Foundry's Nichole Rathburn, Ed Kroupa, Katrina Toft, Ian Holman, Jeremy Gregory and Kirk Hauptman — without their profound talent, my work would be far less.

Many thanks to: Fred Prinz, a mix of dear friend, artist-photographer and scholar; photographer William Thompson, whose works are legendary; Scott Hensel, an accomplished photographer; and gifted photographer Joe Boyle, who shot and prepped many of the photos for publication. Their selfless, creative support was crucial.

Roy Laneville, my hiking and skiing compadre, whose bravery came through when he saved me from my computer.

With deep gratitude to Fred Chernoff, my intellectual conscience, and to Scott Whittaker, my spiritual escort.

Ray Andersson at Artist Studio.

Jan Walker at Plicata Press for her tireless support and willingness to make this book available.

Special thanks to my wife, Lyra, and son, Daniel, for their endless support and love.

Loosen the Light
(Introduction)

Walking into my studio, I put pen to the blank page, or my hands on the raw stone, steel, or clay. What comes next is what comes next, making the unknown known.

My interpretation of my art is only one perspective. No one needs my permission to see sculpture or poetry in a way that pleases or moves them. It is a compliment for me if one finds their own words through mine, if a child is drawn to touch one of my sculptures, or a dog barks or growls at a piece.

Working in terracotta, I find myself using my hands at first. If I am fortunate, the clay embraces me and the figure invites me in. Next, I use large and small sculpting tools. Some of these tools are older than I am.

There are only a few things in life that bring me the hope of salvation: the tears that come with the love of participating in the life of Sitting Bull; or the honor of seeing the beauty in old women—to fall in love with what my hands created, knowing all along that I am just a tool of The Creator and am thankful that through my hands I'm allowed to bring beauty into this world from the spiritual ethers.

Working in steel, my tools of choice are these: a propane forge; a large coal forge; a two-and-a-half pound and a five-pound sledgehammer; a wire-fed welder; a four-and-one-half-inch grinder; an eighty-five-pound horseshoeing anvil that I used for forty years as a farrier; and a three-hundred-and-fifty-pound blacksmith anvil. This is the process that I go through as a man for permission to touch the anima within. When there is no doubt in my maleness, then I allow myself to embrace the anima.

Most of the time, bronze is the finished product of my works in terracotta and steel. After the sculpture goes through the lost wax

process, I chase the piece. For me, it can be as uneventful as instructing the foundry on grinding a few burrs off a corner. At other times, I have found myself working many hours at the foundry recreating a wolf's nose to give it a different emotion or to alter a foot on a human form. Welders and grinders come into play here.

Whether we are actors, musicians, painters, writers, or sculptors, the responsibility to put our hands, metaphorically speaking, into the clay is ours and ours alone.

I only pray that it is for the good of humankind.

Witness

I Have to Sit

My spelling and commas are wild dogs
A frayed leash restrains them

The earth slows down
Yields to my moon-baying on the page

This world is my illusion
A stagnant canyon between sounds

I become tied to nothing
Then everything
A still sky
The endless sound of blood rushing through my ears
God watches and prays

Almost Three in The Morning

My dogs are asleep

My wife is away

One pedestal holds my hundred-year-old sculpting tools
and a tumbler of Talisker whisky glistening in the studio lights

On the other rests a lug of Dover White clay

Miles Davis' Recollections welds ethereal to sinew

Alabaster clay gives way to joy sadness a prayer for women
 love for them

And these beat-up horseshoeing hands reach the gift of
sculpting tools given to me before I knew I needed them
by an old singer-song writer lover who said
 "You just have to have them"

I bring shoulders hips breasts calves thighs

I finish more than green eyes slender fingers grasping

I want Her to draw breath

Bronze is all I have

Lost Wax Process

Bathe Her Dover White clay with milk from a rubber tree
Dries pliant

Womb of plaster bolted swaddles Her pliant cast

Foundry's midwives unlock womb with wrenches
Take Her clay being from the dark

Hot wax floods void
She becomes wax

Slurry of sand dries cocoons Her
She dreams

Alchemy of Crucible's copper and tin flow like lava in
 hardened belly

In wax She's gone
In bronze She cools
Hammers free Her

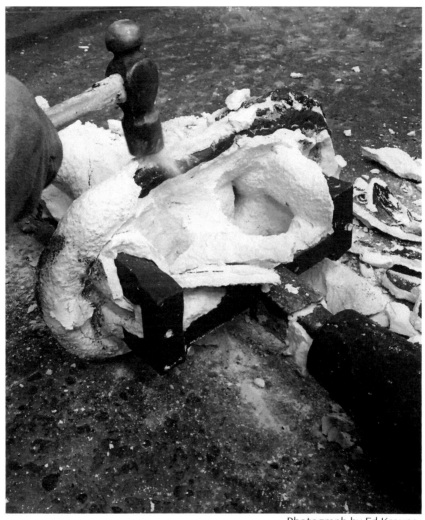

Photograph by Ed Kroupa

Two Ravens Foundry
Tacoma, WA

Patina

Torch-fed heat

Distilled water sulfured potash makes black

Ferric nitrate and water bring dark brown and red

Nitric acid of nails rusting in water bleeds brown

Cupric nitrate becomes green

Her burning-hot bronze body takes it all

She is more than non-ferrous

If you look under Her you can see sand untouched

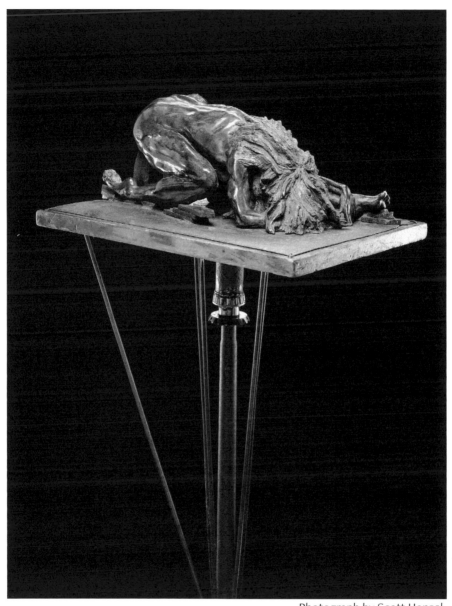

Dyl-Le-En

Bronze

9

Torso

Rearranged in perpetual tide

Arms hold

Then let go

Leaves only memory of passion

Freedom from visage

She shines and shuns

Embraced by steel

Opens to the sun

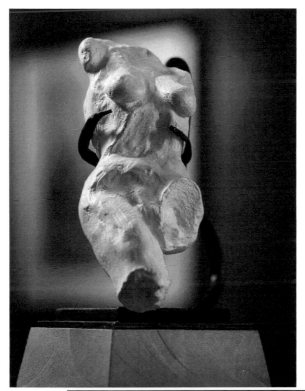

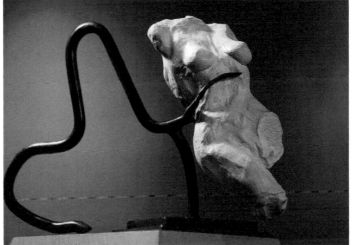

Photographs by Joe Boyle

Torso

Bronze with Dover White patina

YOU THINK I SHOULD CALM DOWN,

shouldn't be mad—obsess about wrongs. Yeah, I am angry. I look over pictures today, trying to find the one shown to me many years ago after sculpting my vision of a Rwandan. The images blast me out of my indifference: a long burial trench full of bodies, pummeled face of a woman holding two young children, crying toddler clutching the flannel plaid shirt that a dead man wears, a thousand skulls in a pile, and a young man, his stitches holding his face together. How is it we don't stand up against bullies? We let them get to us at work, in the schoolyard, in our own houses. Cowardly, we buy products from the corporate world when we know there is a whip inspiring its production. And, worst of all, when we don't fight the bully in ourselves—the passive one, who lets it all happen. Isn't it the little injustices that lead to the larger ones and still larger, until it's genocide?

Rwandan

Some works I let crack, fall apart, and they express more.

Sculptures' truth: dried mud, and metal.

Angst, old as the lug of clay sculpture is made from.

Within the creation, I find us.

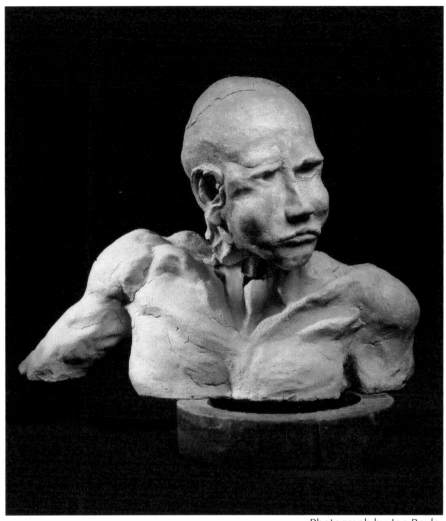

Photograph by Joe Boyle

Rwandan

Terra cotta and steel

Artist's note: I created this bust from my imagination, after reading of the 1994 genocide in Rwanda. Later, following completion of my work, I was shown a picture of a Rwandan. He had an uncanny likeness to my sculpture.

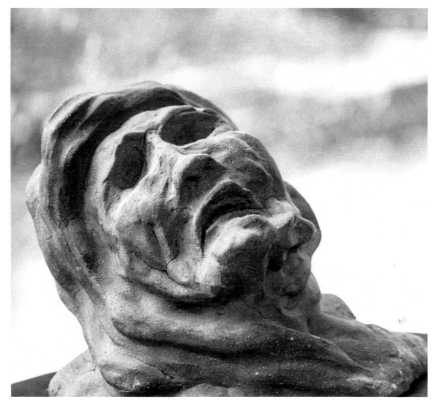

Photograph by William Thompson

Herzegovina Woman

Terra cotta

Again, I created a bust from my imagination, this time after reading of the 1995 genocide in Herzegovina. Following completion of my work, I was shown a picture of a Herzegovinian woman. She also had an uncanny likeness to my sculpture. It's impossible for me to believe anything is done within a vacuum.

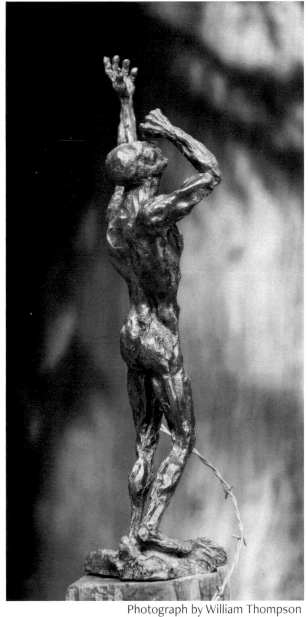

Photograph by William Thompson

Man

Bronze

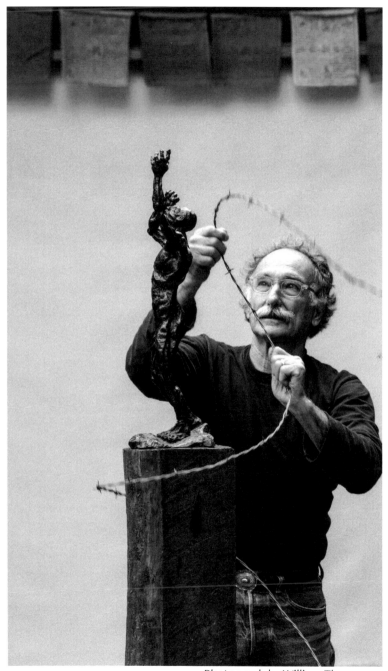

Photograph by William Thompson

Prisoner

At eighteen, I would have enjoyed a trip to Vietnam. But our country's undeclared war in this part of the world left me with no doubts. If the United States Congress was unwilling to sign on the dotted line, and most of the sons of our politicians weren't going, then nor would I.

Mohammad Ali said it best: "I've got no quarrel with the Viet Cong."

In my late teenage years, I worked as a peer counselor at a counseling center in Los Angeles. A well-known psychiatrist, William Singer, was the head of this non-profit. He was also one of the professionals who established the psychological profile for who would be fit to serve in Vietnam. We had become friends.

As I neared draft age, William asked, "Richard, you are going to be eighteen. Do you want out of the war?"

"Yes."

"Good. I'll write you a letter."

Months later, I returned the favor by traveling to Baja, Mexico. William wanted me to see how his teenage daughter, Hanna, was getting along. She was living by the Sea of Cortez in a commune, Shimber Beris.

William had concerns, but he kept it vague enough that I thought it was mostly because of tension between him and his daughter.

A visit to the commune was just as much for me, though. I was on the cusp of old youth and young adulthood, in search of what I should do with my life. While I was contemplating whether to go, a friend said to others, "I bet Richard doesn't do it." I took that as a challenge and went.

Señor Escapada met me as I got off the plane in La Paz. We drove for miles on a potholed, one-lane dirt road in his Willys four-wheel drive Jeep station wagon. He finally dropped me and the commune's supplies off somewhere at the water's edge of the Bay of La Paz.

Almost three hours later, a wiry, older man wearing a straw hat floated up in an a weathered, fifteen-foot rowboat. "Ricardo?" he sung out over the noise of the boat's small, Evinrude motor.

"Yes," I replied.

"My name is Juan Guillermo."

He beached and jumped out of the craft. He wore a white shirt, sleeves rolled above long, strong biceps. The ends of the shirt were tied in a square knot at the waist. White cotton, canvas pants were rolled up above his calves.

Together, we loaded the supplies into the old boat and motored off. We landed on a remote beach, fifty miles across the bay from where we had started. Here, an American man and woman in their late twenties greeted me at water's edge. The three of us unloaded the boat, and Juan started his journey back across. We then hauled the cargo in wheelbarrows, two hundred yards up, to the first of two palm-roofed abodes.

The dwellings looked to be the same size: one-story, about 1,800 square feet. I would never see the inside of the second one. A fence and small trees somewhat hid the dwelling. It was far enough away that if sounds came from it they wouldn't be heard.

In this first building, I dropped my duffel bag and took a deep breath as a ruckus outside the door started.

"You're not going to cut my hair, fuckers."

A handful of men held a slender young man on the ground and a woman with scissors started to cut. The young man had the will to fight, but not the strength. His hair was cut. Later, one of the men involved in restraining him came over to me and apologized for my having to witness this display. I said, "That's okay," wondering if I was next. My hair was long.

The commune's core population was eclectic: an ex-student body president from Stanford, his wife and their two young children; a woman who was a dancer in the original Broadway production of *West Side Story*; a bail-jumping motorcycle gang member who had just gone through heroin withdrawals; and two sons of a congressman. Also there, were two sons of an insurance man, and two brothers who were the sons of a dean at the University of California, Los Angeles. A young, pretty woman with brown hair and freckles, named Peg, ran the commune's daily operations. There were a handful of others. And my friend's daughter.

The commune's needs from the outside world were handled by Juan Guillermo, his wife, and their fifteen grown children.

For the seven months I lived at Shimber Beris, my sleeping quarters were a half-mile past the two adobe dwellings—deeper into the desert or what they call "compo." I slept on a steel-framed, Navy surplus hammock that hung from a mesquite tree. It swung when there was a wind.

My first friend at Shimber Beris was an old Siamese tomcat named Agamemnon. I never had much interest in cats. I'm a dog man and felt it almost an affront to my fellow canines to befriend this old tom. After a few days of trying to avoid petting him, my homesickness got the better of me.

With a great sense of duty, Agamemnon followed me the half-mile each night to my hammock. A week later, he found permanent residence on my chest while I slept.

He was quite the hunter, bringing me small dead birds, lizards and scorpions. He killed a rattler at the foot of the mesquite tree. From that day forward, I was a confirmed cat lover.

On my arrival, I let Peg put my passport in a safe place; at least that's what she claimed.

Once settled in, and within this first week, I had a short conversation with my friend's daughter. She told me she was happy. She did have a peaceful glow about her, which made it easy for me to believe that she was telling me the truth.

As my first week came to an end, I said, "Well, I've seen everything, and I'm ready to leave."

Peg replied, "You need to talk to Dr. Burden. I'll set up a time."

The next day, a slender man in his late fifties with thinning, light brown hair combed back approached me. He wore perfectly polished leather sandals with white socks. His weak gait was aided with a walnut wood cane. Its D-ring, brass handles, when separated, opened into a wide leather strap, creating a single-legged stool.

In an aristocratic English accent, he said, "Hello, Richard. I'm Dr. Burden. I understand you are a friend of Dr. William Singer. Please come with me to my study."

I followed him into the whitewashed walls of a small, narrow office. A citizen band radio rested on a shelf along with books and papers. We walked through the small office into the adjoining and even smaller room. Two chairs filled the office. I sat on the wooden one with my back to the window that looked out onto the desert wilderness. Burden placed himself in the frayed, dingy, patterned armchair. A standing lamp arched over it; a few books rested in the shelf behind him.

"Richard, tell me. How are you?"

"I'm good. I have seen Shimber Beris and I'm ready to leave. Please make arrangements for that now."

"You haven't seen Shimber Beris. I can't let you go until you understand what we are all about. You need to stay awhile. It will reveal itself slowly. We see things differently here. In only a week's time you cannot grasp our beliefs and our unique way of life."

"How much time will that take?

"You need to be patient."

"What else is there to see? I've met everyone, including the twelve goats, four burros, chickens, the tomcat, and five horses. And I've seen the vegetable field."

"You need to trust. You need to understand what we are doing here. We have spoken enough for one day."

"I want to leave. Make arrangements, please."

"After you understand what we are doing."

"I do understand."

He smiled, put his hand on my knee and said, "In good time. For now, my boy, participate in our way of life. We will talk tomorrow."

For seven months, tomorrow never came. His young followers blocked my attempts to meet with Burden.

The violence on the day of my arrival never left my mind. Commune members were too willing to fight and hold down one of their own to cut his hair with large scissors. It was easy for me to fathom that they would do whatever it took to keep me here if they thought I would jeopardize their way of life.

Burden knew that William Singer had sent me to check on Hanna and that William was highly influential in the world of psychology and fund raising.

I was not going to fight a battle I would lose.

There wasn't an easy way to leave. I didn't have a boat. There were no roads. And I had no compass.

I participated in work, and even preempted my fleecing by suggesting my hair should be cut.

The days were quite pleasant, though—aside from the nonsensical sunrise lectures given each morning by Dr. Burden. The forty minutes of classical music preceding his oration was enjoyable.

I am and will always be a meat-eater. It's not my fault; it's just the way I'm plumbed. At one hundred and sixty pounds, I'm slender and wiry. Within a short time of their diet of beans, rice, and vegetables, I was down to one hundred and twenty pounds. The food just went through me way too fast.

I believe in providence. Only a few hundred feet from my hammock was an abandoned troop tent liner, draped over what was left of the tent's framework. The canvas liner was drafted into service as my personal toilet paper.

I was given jobs tending goats and horses. Later, as a now trusted member of the group, I was appointed to be a lifeguard when we swam in the ocean. The Sea of Cortez is calm; while watching everyone swim, I thought if only I was a very strong swimmer, freedom would be mine.

We all had our reasons for being there. Mine was to return William's favor. My underlying reason for traveling to this commune was to attain a deeper understanding of the world and myself. I've always felt so different—left out. I never understood the allure of baseball. The concept of a watch never intrigued me. So much of my childhood was spent wandering the hills, deserts, and mountains, never believing I had to conform to the flawed social structures of school, the assembly line, or the rigid framework of religion. Clothing made sense for protection from the elements, but not as protection from the attraction of another. It seemed to be a misstep in being civilized.

I soon found that I couldn't access the viability of enlightenment gained by the others who lived at Shimber Beris. For me, it was a prison ruled by a crazy man.

Burden's true believers held onto me, while several others came and went with apparently very little fanfare. In a short time, I became aware that the only way out would be to appear to embrace the people and the philosophy.

Burden's early morning lectures were accompanied with his reading of a story that seemed to be endless. Two characters dominated the pages, and from what I could tell, they were supposed to be the next generation of humans. They were not male or female. Is this what he wanted for us?

I was in my own world—listening to my own thoughts, unencumbered by any responsibility of regurgitating what Burden said or read. He seemed to be interested only in hearing himself talk.

My most pleasurable moments during my stay came late at night, when Agamemnon would fall asleep on my chest under the midnight stars of Baja.

I dreamed of the day I'd leave, when they were totally convinced I was one of them. But at the seven-month mark of being at Shimber Beris, I sensed Dr. Burden and those closest to him had a sanctimonious paranoia about my faithfulness to Shimber Beris. Though I was accepted by the members, I refused to pretend to gush over Dr. Burden's words. Therefore, I felt Burden was uneasy about me.

This was the late 1960s, when any group that was out of the norm was called a "commune" or "alternative lifestyle," denoting a self-contained, bucolic setting. This place was anything but bucolic or self-sustaining.

Like other communes, Shimber Beris was a curiosity for the voyeuristically inclined.

Burden cashed in on the 1960s phenomenon of communal living and allowed well-vetted individuals to visit. These few who made the trek to Shimber Beris seemed not to be seeking truth, but only the image of seeking. They'd stay only a few days; as they were leaving, they would tell me they had now completed another part of their spiritual quest, as if it were a scavenger hunt.

All my letters, incoming and outgoing, were opened. One of my outgoing letters was handed back to me for correction—instead of writing Hiller, I wrote Killer, when referring to one of the true believers. My incoming envelopes were taped over with one small square of Scotch tape in the middle.

John came to Shimber Beris five months after me. He was a bright 27-year-old, Phi Beta Kappa, University of California grad student. Eight weeks after his arrival, he left.

The day before John was to leave I took him aside and asked if he would take a letter to an older friend in the States who would do whatever it took to get me out. With all of his declared intelligence, he managed to not immediately stuff the letter in his pocket. He just held it in his hand, as if it were a baton in a relay race.

As he departed, the true believers in the group were, as usual, staying on vigil. They grabbed the obviously handed-off letter. In that letter I revealed how I wanted out, but hoped I couched it in such a way that if it fell back into the hands of a Shimber Beris devotee, I would not do too much damage to myself.

Of course, within the next morning's lecture, after the story of what I believed to be Burden's version of an asexual Adam and Eve, he started to disparage this lowly soul who would jeopardize the lives of everyone, this betrayer of everything, this empty soul—me.

My time was up. Burden left the room quickly, after his thinly camouflaged order for his true believers to have their way with the villain in their midst.

I wanted to be free or die. I didn't care which anymore.

The small room where we listened to Burden was where his most trusted congregated.

At the top of my lungs, I yelled, "I want the fuck out of here." The men and women grabbed me. In my confusion and utter rage, Heather, one of the members, held me. To my bewilderment, she cried and uttered something amidst her sobs. It registered as love for me. I was totally confused.

I became weak and almost wanted to stay. I felt for the first time the love of something other than a dog or cat.

They calmed me down, and with that, told me they would make immediate arrangements for me to leave. It would take two weeks.

At this point, Burden wanted me out as much as I did. So while waiting to leave, I was sent away with a seasoned member of the group named David. We hiked twenty miles beyond Shimber Beris, deep into the desert, with two burros carrying our supplies. Our destination was a small oasis.

For two weeks, twenty miles up this burro path, under the deep shade of palm trees, wearing no clothes, we patted out corn tortillas, rested and swam in the oasis lagoon.

Stripped of everything, the essence of who I was and who David was revealed itself. What I saw in David was a wonderful human who, to this day, I remember kindly. I don't think I ever thanked him for spending this time with me while I waited to leave.

I didn't want to leave the palm trees, desert spring-fed deep pools, song birds, and isolation—now that I was beyond earshot of the stupid, egomaniac Dr. Burden.

Despite my fear which had turned to anger, after working and living there for seven months, I had become part of this commune.

Two weeks later, back at Shimber Beris, a few people came and said goodbye to me as I waited on the beach for Juan Guillermo to take me to La Paz.

Back in Los Angeles, my ride barreled through overpasses and underpasses, and I thought how cartoonish to go this fast. How could it be that important to get to where we were going so quickly?

I had come back to Los Angeles, back to the craziness of our over-consuming and hyper status-seeking culture. It was clearer to me than ever before that the average person was easy prey for the egomaniacal, whether it was Dr. Burden or a big business man who puts profits above the earth, humans and other creatures. The old saying, "He'd take a dead fly from a blind spider," will always be true for this kind of man.

No longer would I participate in giving such people power, whether it was a lone psychological bully running a commune in the middle of Baja, or a corporate head in his palatial home.

In contrast, I no longer saw myself as flawed because I didn't want to or was unable to fit in.

Over forty years later, my friend's daughter could still be living in some vestige of Shimber Beris, though the commune has formally disbanded. The irony of it all is that after my conversation with the daughter within that first week of being at Shimber Beris, I truly believed she was happy there. And, unlike me, she did well on a vegetarian diet.

Agamemnon, my best friend at Shimber Beris

Red Rock Canyon

Lose sight of the transient star

Desert wind blows time

Dream of a slender, freckle-face woman with emerald eyes

Horizon swallows burning star

Dusk's shallow sight fades chaparral into rock

Cool sands wake

A clean slate of night

Wait for dawn

Talons find a mouse

It's A Dark That Sunlight Can't Penetrate

The making of my mind, not the absence of light
The radio shuts off at two in the morning and I hear me

The opaque sound at the end of an empty hallway,
 full din of dusk's gloom

Black thickens
My hands disappear in the gloaming

The Illusion Is We Don't Know

We know everything in the way we know our heart's beat

Every un-kept promise

Every kiss not returned

Every child not held

Even the world before this one

Everything Else Broken

Bottles of spices thrown into the cardboard box on the kitchen floor;
not one bottle or anything in the kitchen broke.

Iron pots and pans, mugs from pretty places, candleholders,
napkin holders, sets of plates and cups, careened into boxes.

How do I say to friends that *the story they created for their lives is
no longer the story of their lives*?
I didn't have the words because there are no words.

The court comes up with words that get the job done, but the words
are never quite right.

The handmade mugs came next. They weren't thrown but debated.
She wanted this one, and so did he.

Earth's Changes

My friends

My family

Our animals

Some slash onto the page

Some burn away

Moving on whether wanting to or not

Eternal beliefs don't stay

Fragile memories never leave

What illusions I'll make

What ones will be made for me

Bear witness to my dad getting close to the other side

Too close

Vision
Leonard Steven Heller (1924 - 2014)

The only freedom is imagination

I envision wings and gills

Leaves falling in summer

To be everything I'm not

When heat, hunger and cold are empty promises

And a grave is not filled with my father, only his bones.

Aria

Throw stones at the rock and yell at the trees; they don't care.
Demand my presence be known.

Pound my head against boulders.
Nothing moves.

Yell at those who pretend to listen.
They leave as soon as it's safe.

Tired of story, my tongue flails and looks for a hymn.

Speak

If We Didn't Have Words

would we think in terms of love and fear

would we understand the things that seem to not be understood

was it the sign of societal decay when we started to talk

emotions are handed down to me in retail fashion by the use of
the inevitably, always misunderstood word

there are times when I have to pry my lungs, lips, and tongue open

I'd rather pretend you silently wish me well

Truth and Beauty

I was seventeen

I wanted her old

Garden crouching

Weed pulling

Bouquet making

Ballet body

She slammed against my youth

Wrinkled hands grabbed me

I kissed her gorgeous honest lines

Beach

Somewhere after midnight

I must accompany the waves with song

No one can say my voice is bad

Hours before the sun

A walrus sleeps near the deafening surf

Dr. Joe,

There are brave men who take lives and there are braver men
 who save lives
You're the latter

I am blessed by knowing your strong artist's hands
Your kind heart

In my thoughts, you're in my hospital room fending off
The noise and vibrations of ignorant doctors and nurses

Shielding me

May you always find a cool summer breeze
A winter's fire
A heavy patchwork quilt to keep you safe
And good whisky to share

Wallace
b. 1272 - d. 1305

I see a life through the cracks of this one

Wrapped in wool

Dream sleep

Hands and feet scramble

Taste breath of yarrow

Drowned ships in the North Sea

Remnants of rosewood, oak, and iron rebel

Bear time

Hold castles

Keep men

Dead volcanoes rise to mud

William's war clouds loom

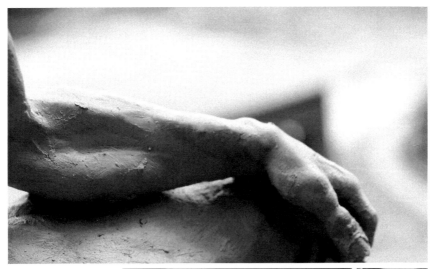

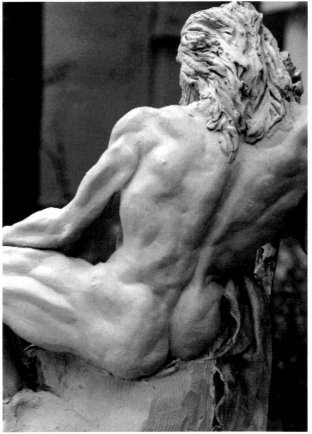

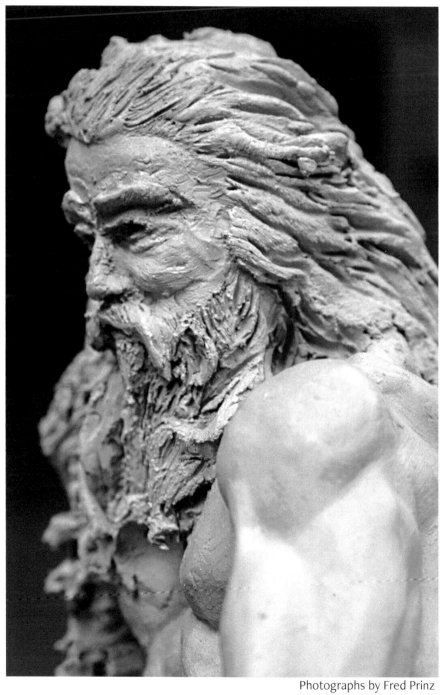

Photographs by Fred Prinz

William Wallace
Clay

My Life

sitting in the bathtub waiting for the muse
like the rest of my lovers She comes when I'm not there
seeing you on the page, Mnemosyne, gives me hope
I remember the days when I lived in the park with Billy
it was Billy a breed from the Shetland Islands
and all those actors
all of them ten years my senior
my life was the same as theirs
but with no checks to write
I was strong enough to eat from other's plates
enzymes in my mouth were once as viable as a dog's

everything for me goes back to Scotland
the first man I loved like a father
my first dog
the woman from the Isle of Skye
Scotland, nothing lives there any more
but the people, they have more than smiles
they don't need smiles
the forests are gone
sheep dirty the hills
not knowing the reason I went to Scotland
 was to find love
the man who tried to parent me is dead
Billy ravaged and killed by coyotes while defending a goat
I got on a bus from Glencoe going to Glasgow
 and watched a drunk get kicked off in the rain
what I would rather have seen was a Scottish wildcat picked up
 by a golden eagle
in flight the cat would get the better of the bird
 and they would fall out of the sky

I am a stranger everywhere

Punctuating Time

Five Years Old

Occasionally, my dad would take me to work with him. He'd park his two-year-old, green '55 Chevy coupe right off Santee Street in downtown L.A., across from the fabric house he managed.

There they were, strong men in blue, wearing white gloves, controlling trucks roaring fumes and rolling on rubber.

With their guns holstered, they'd see us coming down the city crosswalk, my dad and me. I'd say hi. These same hands that stopped and started the asphalt's quake reached out of nowhere and handed me Bazooka bubble gum, and I'd look up past the gloved hands, past the beautiful copper medallion with its modern castle towering within the badge's braided borders, to smiles and powerfully perfect hats.

Six, Seven, and Eight

Barreling down dirt roads in the San Fernando Valley with Grandpa Joe, always in a new Cadillac, the next stop was to train a horse or look at a McNab shepherd, and go to a bar where his personal shot glass waited, and get a speeding ticket.

Not one for much conversation, Grandpa would say he was sorry, grab the ticket and, out of sight, start speeding again. The police looked surprised when there wasn't an argument, only pleasantries coming out of this older man with the bald head, a big mustache, muscular arms, and a thumb missing.

Fourteen

In the middle of the night, Alan, a family friend, drove his new, light brown and white International Harvester Travelall station wagon. His ten-year-old son, Mike, sat in the seat behind him. Alan's other son, five-year-old Mark, sat between Mike and me. I sat behind my dad, who was riding shotgun.

We were on our monthly weekend trip to the ranch, my World War II jeep in tow, to explore the desert after some ranch work.

We traveled deep into desert silence, down the steep grade out of Newberry Springs, twenty miles east of Barstow, California, when a state highway patrol car's glaring, scarlet lights splashed against us in the dark.

"Let me see your license."

Alan replied, "Sure, officer, but what was I doing?"

"You were speeding."

"Oh, come on, I couldn't have been going that fast…maybe on the downhill grade a little, but that's all."

The patrolman responded, "Get out of the vehicle now!"

Alan replied, "What, are you kidding?"

The patrolman swung open the Travelall's door, grabbed Alan's arm, and shoved him against the rear passenger door, the side where his son Mike was sitting. Alan's back pounded against the passenger door's window over and over again. It moved the Travelall like a gust of wind.

My dad and I got out, yelled at the patrolman. As we moved toward Alan and the patrolman, the other officer, the taller one from our side of the truck, pulled out his revolver. He told my dad and me to get back into the vehicle. We obeyed while looking down the gun barrel.

Alan's face was now pressed against the truck door's window, with his left arm pulled up behind him, high and tight, while his sons watched from inside. As Alan struggled, he tried to talk to this violent peace officer. Then, with all the pushing, grappling, and yelling, the right words suddenly came out of Alan's mouth—the words that saved us.

"I can't believe this is happening to me."

The officer let go of Alan. He got back into the driver's seat, while the patrolman wrote out an abridged edition of what just happened in the name of a speeding ticket.

We drove to the ranch in silence. Later, a lawyer's letter got Alan an apology and gave the bully in the tan uniform a slap on the wrist. Only now, forty-one years later, do I get my revenge on this page.

Still Fourteen

In the early evening, I stood with my friends Art, Dave, and Bucky near the corner of Western Avenue and Hollywood Boulevard.

This intersection was where good and bad merged. We were good.

Fast, hard footsteps passed us; the bang of a .38 sounded its arrival into the flesh of someone's German shepherd standing near me.

The LAPD had lost its aim, missed its robber. The bullet's wind touched my skin like a fast whisper. The dog was dead. The police didn't look friendly, so my friends and I left.

In the paper the next day: "Police looking for witnesses."

I didn't reply.

Fifteen

On the back of Art's motorcycle, hauling ass around the corner of Western and Hollywood Boulevard, I saw a 12-inch Proto adjustable wrench in the street by the gutter.

"Art, go around the block," I said. "There's a wrench in the street.

We turned the corner. As we got close to the tool, a motorcycle cop at the light leaned over and picked it up. We pulled alongside; I said it was mine. He handed it over to me with a kind smile.

Still Fifteen

Immaculate Heart High was an all girls' school built at the top of Western Avenue, against the Hollywood Hills. Once a month, they'd have a Saturday night dance.

Pushing the boundaries, trying to find something, my friends and I stretched the meaning of dance. Artistry needs to be expressed. To this day, all I can figure is the story we were trying to tell with dance was that we had the ability to breed. Our Marshall High School vice principal had said it best, when he caught us performing the same choreography at a Marshall High School dance. "That's not dancing. That's perverted gyrations."

The nuns saw it the same way our vice principal did and called the police.

The men in blue pulled out billy clubs. Somehow, a few of us knocked the clubs out of their hands. I knew we were in for it. I faked being in terrible pain when I was restrained with a hammerlock. They removed us from the old brick monastery's auditorium to the flagstone patio. It was there I mimed police brutality, not uttering a word. I cradled my so-called injured arm as if I was consoling a crying baby. They let me go. I had learned my earlier lessons well. My friends got in trouble.

Sixteen

I had two weeks under my belt as a licensed driver. I drove up Larchmont Street in Hollywood and made a left onto Melrose Avenue. Before it registered in my mind, a motorcycle cop signaled me to pull over. I pulled over.

"Do you know what you did wrong?" the policeman asked.

My reply was honest. "No."

"You didn't yield the right-of-way to oncoming traffic."

Even though I didn't see that I'd done anything wrong, I believed the officer, and I took my ticket without a word. I felt kindness and concern coming from him. Like, "Hey, kid, wake up. You're not out here alone."

Eighteen

I was pulled over by a patrolman on the Hollywood Freeway before the Vine Street off ramp. I was ready to take a ticket for speeding, because I probably was. Unfortunately, a little more came my way.

The "man" decided to start yelling at me. It was a blur, as most times it is when I go into a rage. I don't remember a thing he said. But I remember what I said back to him. "Why don't you take off your fucking Girl Scout dress and take a swing at me." He got into his patrol car, and quickly drove off. I got into my car and started to chase him. Even now in my fifties, I thank God that something overrode my rage. I took my foot off the accelerator.

Twenty-Two

My girlfriend didn't want to drive home late one evening from Malibu in her '62 VW Bug with its mangled fenders and misaligned headlights. The five miles to our small ranch in Cold Creek Canyon was dark, full of hairpin turns. She drove my healthy pick-up home instead. A few minutes later, I followed in the VW with Cashew, my girlfriend's half-Lab, half-Australian shepherd. Cashew had grown attached to me.

On the darkest part of Malibu Canyon, a row of lights on a sheriff's car flashed.

One of the deputies told me to get out. As I closed the car door behind me, the dog's big teeth blazed. He barked and growled with the repetition of a machine gun while he pushed against the car's window to get out. One of the deputies pulled his revolver out of its holster, ready to shoot the dog, maybe through the window. In a calm voice I said, "You don't need to shoot him. I can settle him down," and I did.

There was someone out there with my name, brown eyes instead of blue, an inch taller, ten pounds lighter and a little younger, who wasn't paying his parking tickets.

I was the only one in the holding tank that night. After a few hours, they let me bail myself out with the sixty bucks I had in my wallet. A few weeks later, I proved to the court that they had the wrong guy. Could it be these arresting officers didn't know how to match descriptions, something any fourth-grade child could do?

Forty

April 29, 1992: I was making my way down La Cienega Boulevard from our home in the Hollywood Hills to my son's grammar school in Culver City. The "not guilty" verdict for the LAPD officers who had beaten Rodney King had just come in.

Fire seemed to be everywhere. The rioters, protesting the verdict, were running in and out of stores, looting and fighting, while the police hurried away from this brawl they'd started.

Halfway to my son's school, I turned back and got my shotgun from home. On the way back in my beat-up old Toyota pickup, a young man in a car next to me pointed his pistol at me. I raised the shotgun, level with his face. He gave me the peace sign.

Fifty-Three

It was seven o'clock at night on the corner of Hollywood Boulevard and Vine Street. I waited at the subway stop to pick up my wife. A white man's drunken, ruddy face appeared at my truck's open window. I could smell his alcoholic breath as I pushed his face back out the driver-side window. Over and over again, he kicked at the truck's door. I got out the other side, took a swing at him and missed. It was such a hard swing that it left me stunned on the ground for a second. I got up as he started to kick at me. I deflected his feet, took another swing; this time, I connected. He walked off. A few minutes later, he came around from behind me, hit me in the face and ran off again. I tried to get someone to let me use a cell phone or to get a storefront owner to call the police.

A tall African-American man who looked more capable than I came forward and said, "I called the police for you." When, once more, the drunk man showed up, he stayed a safe distance away. I started to go for the drunk, but the man who called the cops for me said, "Let it go, man, let it go." I did. The police showed up on bicycles. They asked me what was wrong. I told them. Their reply was, "What do you want us to do about it?"

"I want you to catch him."

One of the men pedaled off in pursuit while the other one asked me, "Why are you down here?"

"'Cause I live here. I pick up my wife from the subway every day."

I thought to myself, I'd probably be the one to get in trouble, even though the drunk was a foot taller than me and probably out-weighed me by a hundred pounds. This drunk will sue me. I'll have to spend time in court. I told the cop to forget it. He radioed back to his partner. I found a safer place than Hollywood Boulevard to pick up my wife.

Fifty-Five

A stout, panhandling bully entered Starbucks. Making his apparently successful rounds, as he got to me I said, "No, sorry." He glared. I smiled as he gave me the finger. His next stop was the restroom, which he still occupied thirty minutes later when the LAPD showed up for coffee. I went up to one of the officers and said, "There's an aggressive panhandler in the bathroom who has been intimidating people in here."

The officer replied, "I'm on my coffee break."

Fifty-Six

At midnight, my son and I, with his Siberian husky, drove past Sacramento, California, on Highway 5. My son's truck was full of his belongings. We were on our way to Bastyr University in Kirkland, Washington, when a vehicle came up behind us and flashed its high beams.

My son thought something might be wrong, so we pulled over. The truck pulled in front of us. Another vehicle appeared behind us, trying to box us in, while the two men in the front truck jumped out and ran toward us.

As I started to get out to fight them, my son said, "Dad, hold on. We're getting out of here."

I didn't really know what was happening as our wheels spun back onto the asphalt. The two trucks were now chasing us.

My son's truck looks old, slow, and "stock", but it isn't; they couldn't catch us. At the same time my son was getting us out of harm's way, he was on the cell phone with the California Highway Patrol dispatcher. I went into a rage, wanting to kill the men in the other trucks.

The dispatcher exchanged questions for answers. Then she said, "Tell your dad that his son has it handled, and to stop yelling so I can hear his son."

I went silent and started to shake as I saw the two trucks try to force someone else off the road. The dispatcher asked, "Without getting in harm's way, can you get a license number?"

My son said, "Yes," as he slowed down to swoop in towards them. With one hand on the phone and the other on the steering wheel, he calmly gave the one license plate number he could read.

We watched a CHP car fly past as we were escorted off the freeway by another patrol car.

I tried to talk to the patrolman, but my teeth chattered so violently I couldn't get a word out. Sweat poured out of me in the forty-degree weather. I was shivering so hard that the truck's interior vibrated. The officer asked, "Is he going to be OK?"

"Yeah, my dad just gets that way if he feels scared and doesn't do anything."

I shook less after the patrolman told us they caught one of them.

Words Leading Me Home

It's a home that has no walls, no ceiling, only sky;

no floor, just ocean under my feet.

Under fish, above birds I swim.

When I fly, I crawl in the darkness.

Sentence after sentence till it's a book.

I prop it against the next door and write my way through it.

An Embrace That Lasts Longer Than Fear
 For Jen and Stephen

The heavens thank you for one more day of believing in love

One more juicy kiss

Skin touching skin

A memory for your grandchildren's children

Though they might not remember your names

Mother's Sun

Alone, my wife walked on thorns, pretended they were roses.

In the shadow of knowledge, she'd travel on the souls of sages.

The stride of a thousand years let these truths be free.

She believes in kites that have no tether.

Old men tortured her; so have young, as matriarchs bound her.

You can't touch her.

She needs love.

She finds me.

She wears a golden locket and forgets her heart is in it.

Son of mother's hair and spirit raise the day, guard the night.

She doesn't look back; it is the beginning.

Our child breaks the bars of her prison.

Her dead mother's curse is broken.

In the garden we wait; my wife does come.

Thorns now adorn the fence; petals on the ground cradle her
 bloody feet.

She is home.

Come dream, rise with a Son.

You're out of the shadows.

Your locket melts.

Dyl-Le-En

Three women in my life have shown me what good women are:

The first one was like a mother

The second was a woman I had a crush on who was a few years
older than me

And the third was a woman I dated who liked me
just the way I was.

To You, Lyra

It's this way that I bend

And not pass the hate

Dirt and horses' sweat on soapy rags draped over a big, rusty can

In sunlight

I hear our laughter

We clean the tempered, straw-colored steel of a summer

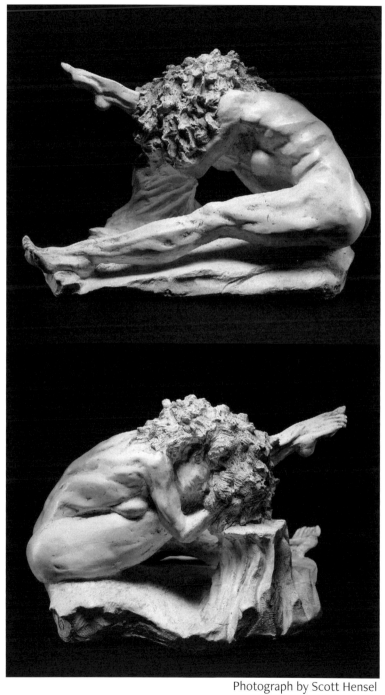

Strength

Clay

Sitting Bull

A few years ago a friend asked, "Richard, would you do a Thanksgiving sculpture for the front window of my hair salon?"

"Sure," I agreed.

I started sculpting a turkey out of terracotta. Sometimes things become a social and political satire in my hands. The bird morphed into an angry thing that would give you indigestion. I threw it away.

I then decided to sculpt a Native American. I surrounded myself with old pictures from my wife's anthropology books, looking for the "wooden Indian" in front of the tobacco shop.

The bust was finished eight times and squeezed back each time into a lug of clay.

My eyes focused on black and white photos, sad faces of men too brave to shed a tear.

Crazy Horse, Cochise, Geronimo, Seattle, Red Cloud, and Sitting Bull stared back at me from the pages.

In a fever not of my own making, Sitting Bull pushed the clay in my hands.

In his childhood, Tatanka Iyotake, or Sitting Bull, was named Slow. There was nothing slow in finishing this sculpture. The scars and broken nose tell of his hard life, so I left them there.

I chose not to sculpt his eyes. Taking in the entire piece, I hope, will lead one to imagine eyes, and, if you will, the window into the viewer's soul, not Sitting Bull's. He's been trespassed on enough.

For my friend's Thanksgiving window, I sculpted a vulture.

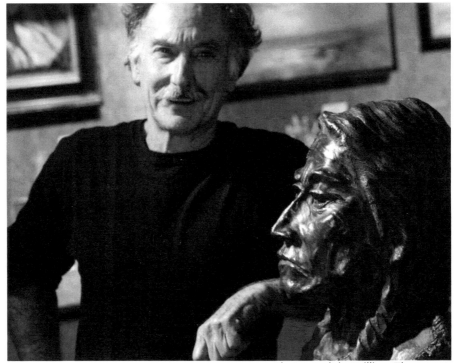

Photograph by William Thompson

Sitting Bull

Bronze

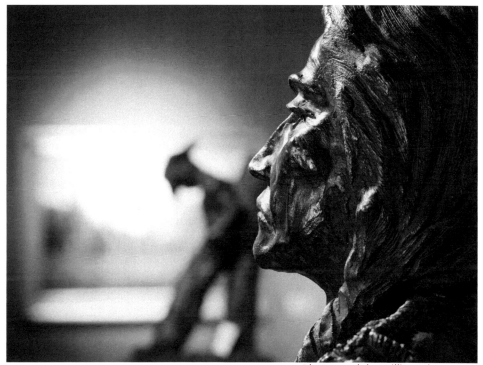

Photograph by William Thompson

Sitting Bull
Bronze

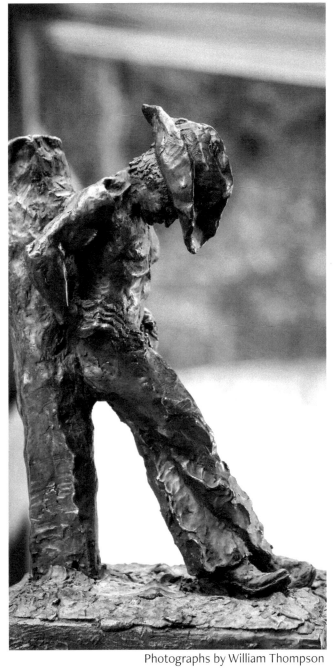

Photographs by William Thompson

Done
Bronze

As a young boy, I pretended to be a horse. The children in my class played along. We ran free on the one-acre grass field, chasing each other.

What is beautiful, faster and kinder than a man?

A horse.

And hooves became part of my life...

Photograph by Maryann Jorgenson

Done

A Rough Thirteen Months

1

For years, I wanted to stop shoeing horses; I only wanted to write and sculpt.

Through my fingers, clay and the written word yield to the dictates of something other than me. But I had a family to support and horses that I loved, so I continued to shoe.

My exit from shoeing finally began at Marla's ranch in 2007, after thirty-five years of working at the anvil.

The horse suddenly moved. Blood splashed from my hand onto the hoof and horseshoe. The sharp edge of the gelding's hoof had sliced one of my fingers to the bone. I quickly rounded off the hoof with my rasp. Marla drove me to the hospital.

2

Tommy Gallon

b. 1923 – d. June 2007

He was my friend and mentor.
He was ready to go, but I wasn't ready for him to leave.

3

A young equine veterinarian tied her horse too close to where I was shoeing. Before I could jump out of the way, her four-legged patient kicked out at the gelding I was shoeing. My horse returned the favor. I was holding his front left leg between my thighs when he sent me and my shoeing tools under him. The gelding's hooves played hopscotch around my head. Black and blue and bloody, I finished shoeing, went home with a headache, glad to be alive.

Done

4

My dear friend and cousin, Felice, died of cancer in 2007; she was fifty-three. She was a powerful spark who didn't have time to judge, only to love and live. Felice raised her little boys to know that they were always loved.

5

The old Arabian gelding I was shoeing blacked out as I reached across and under his belly to measure the length of his opposing hind hoof. He fell on me and then rolled off just before my ribs started to give. I had a hard time with a sneeze or a laugh for a while.

6

Chris was a bike riding, skiing, and camping friend. He died in an avalanche, January 2008, at sixty years old. Wherever I happened to be, it seemed he would turn up—a ski lift, camping on a ferry in Alaska—he would be there, pushing me to go a little farther and never slowing me down.

7

A young mustang filly kicked me hard in the arm. It took two months for the swelling to go down, longer for the black and blue to go away. Months later, I still felt it.

8

Thomas Kirkwood Hamilton was like a father to my wife and me. Thomas died August 2008. He had used his body and mind as a precise tool. In his eighties, he moved on. His love remains.

9

As I drove the last nail in and out of the hoof, but before I could cut and clinch it against the hoof wall, the horse pulled away, sending the horseshoe nail down to the bone in the palm of my hand.

10

Becky Gallon was a lifelong friend and Tom Gallon's daughter. She died of cancer in 2008. She was in her early fifties.

11

A girl leading her horse too close bumped the one I was shoeing. My horse moved fast, stepping on my foot and, at the same time, knocking me to the ground. I left with two broken toes and a sprained ankle.

12

Magnum 44 was an Appaloosa stallion that I loved. He liked to be close to me and I to him. Magnum died of old age in 2008.

13

It became clear, after all this loss and injury, that it was time to put into motion plans that had laid patiently still for way too many years.

No longer could I wait for the promise that was made to my wife and me three decades ago by her business partner. That promise: If we committed to five years of sacrifice, there'd be a prosperous outcome for the two of us. Unfortunately, after more than thirty years of sacrifice, prosperity never came true for us, only for him.

Finally, nothing would get in my way. I'd buy the ranch of my dreams, though now much smaller than I could have afforded thirty years ago.

Out of nowhere, a crazy woman attempted to slander a kind ranch owner, several large animal veterinarians—who truly did God's work—and me.

Done

As I led a horse named Bambino out to be shod, I made the decision to postpone my plans of retiring from shoeing and remain in Los Angeles till this person was put in her place. I would join a possible class action suit to fight with the others she was attacking.

At the moment of the decision to fight, I heard a crack; looking all around, I saw a low, angled, huge sycamore tree falling toward Bambino and me. Old Bambino, this gelding, moved faster than I thought he could. We both lunged out of the way into the ivy embankment. As he leaped over me, one of his hind hooves knocked me in the head, popping out both contact lenses I wear when shoeing. Once again, my head ached as I finished shoeing a horse. It was then, after thirty-five years of shoeing horses, that I said I'd had enough.

Other neighborhood horseshoeing customers gathered in front of this huge fallen tree, which destroyed a parked car and blocked the street. It was then and there that I told them, "I've retired and I'll be moving on."

Done
Terra cotta

As my own model

Photographs by Richard Heller

Photograph by William Thompson

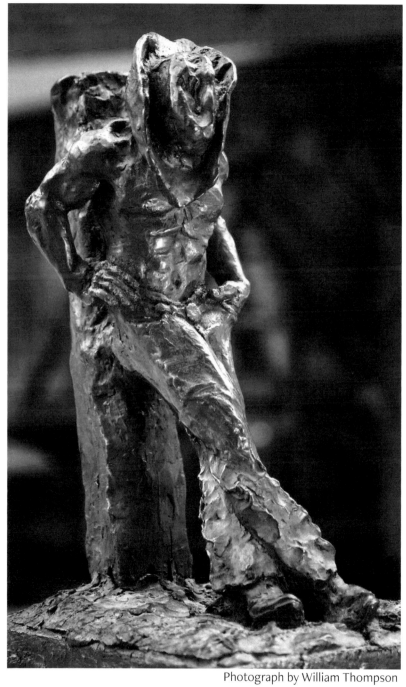

Photograph by William Thompson

Done
Bronze

The Great Divide

Twenty-three sunny degrees this morning, no wind, and it's my first time skiing Banff's Canadian Rockies. Trying to avoid ice on my dull edges, I stay on the few black diamond runs that are out of the shadows. The southwest runs off Goat's Eye chairlift are vast, steep and almost empty of skiers. I watch another lone skier go under boundary ropes, sign attached, "Beware of Avalanches." He wants to get to the good stuff—powder, no ice, no other human tracks. I want to follow. It seems safe.

There hadn't been much snow this year in the Rockies. But would it be like thumbing my nose at my friend Chris, who died last month in an avalanche while skiing?

I go up to the rope, but I don't go under it. I take a moment to mourn—to remember my friend's wonderful energy—and I struggle to hold back tears.

Would he have liked me stopping out of respect? Or maybe he'd be crying in the clouds—that I hadn't crossed the line and skied on the side where the virgin snow begins.

The way from Goat's Eye to the lift they call Great Divide—for it's on the continental divide—is a long run. A local man, half my age, joins me on the Great Divide chairlift.

I comment to the air as much as to him. "It doesn't get any better than this!"

"I agree. Where're you from?"

"L.A., California. Now, don't kick me off the lift," I reply.

"No, I wouldn't do that. I was down in Los Angeles with my dad a year ago. He wanted to take a trip, just the two of us, before I got married in the spring."

"Where do you live?"

"Just in Calgary, but I've lived all over the world with my parents. My dad is a professor."

"What does he teach?"

"Dentistry."

"What kind of work do you do?"

"Website design for Harley-Davidson; it's challenging, pays well, and they're good to their employees."

"Everyone tells me I've got to get a website for my work."

"What kind of work?"

"I'm a sculptor and writer. I don't want to read e-mails, package work and send it somewhere. I want it in a gallery, let them sell it, and I'll keep working in my studio."

"More or less that's what I do: design, meet, and explain, then get back to designing. The less I have to explain the better."

"Right. The better the design, the less we have to say."

School Days

The third grade came in like another set of lethal waves, crashing me into the sand, just as the second grade had done.

What I remember most about school that year was not the pain inflicted on me, but how another student was abused. With the anger that should be reserved for people who murder, the teacher came unglued at my classmate—an eight-year-old girl.

"What is wrong with you? Just look at what is up on the board and read it now! It's right in front of you. Are you stupid? I have lost all patience with you. No one should have to put up with you! You are a worthless little girl."

The young girl stared vacantly at the blackboard without a tear. I felt terrible sadness for my fellow student. I wanted to hit the teacher. I clenched my fists. I wanted to say, "You're cruel. What gives you the right to be cruel?"

I stayed quiet, knowing my place. My life with my mother and father was so precarious that I lived in fear of not having a home.

A week later, the girl returned to school with glasses and was able to read what was on the blackboard.

The teacher did not apologize to the class for her brutal outburst, or to that student who received it.

Enraged at the teacher for not asking the girl for forgiveness, I wanted to say, "Don't you owe the class and the girl you screamed at an apology?"

The teacher had attacked me the same way a week before. I was filled with rage, but my anger was tempered by the feeling of being deeply flawed. So, I didn't stand up and defend us.

Should I have fought, whatever the outcome?

It's always a child's dilemma.

Snap Back at Rudyard Kipling's IF

If it's not on Kipling's list to

laugh at my own thoughts

cry at a loved one's wedding

kiss my horse Sparky

trill a sour "Old Man River" with my friend Jay under stars by
Sierra's Silver Lake

listen through the night to a friend mourn the death of his
deserving Welsh Corgi

dance and almost miss Lyra's toes

hug my drooling Great Pyrenees as he silently tells me
everything will be okay

hold a fellow artist's crying baby who pauses while his mother
reads her notes aloud

reply in kind to the gaze of a baby held by a woman in line on
the plane waiting to get to their seat; I say "Hello, how are you,
you're entering this life and I am slowly exiting. I will see you a
long, long time from now on the other side."

or not adopt the horse I'd driven six hours and over the
Cascades to see, when I saw his worn-to-the-gums teeth, but
still let him get under my skin as I drive home alone

Then why be a Man?

The Reading

I boarded the shuttle for Los Angeles Airport after the ego-boosting, L.A. reading of my last book. In bumper-to-bumper traffic, I thought that I would miss my flight—thus another night away from my home in Gig Harbor, Washington.

The nine others in the vehicle echoed their versions of the same. The driver from Turkey feared missing his grandson's third birthday. While manning the steering wheel, he twisted the radio knob, but it brought none of us relief from our thoughts.

We started talking to one another. The three in the back were from Australia and had been in L.A. for an ecumenical conference. In the row of seats in front of them sat an Irish rock band's lead guitarist, female vocalist and their bass player, all sporting multiple piercings and tattoos.

Seated at the end of my row was a young woman attending college; next to her was a cosmetic saleswoman.

My turn to share why I was in Los Angeles came last. Still hyped up from my fantasies of being the first person to read his Pulitzer Prize-winning book at Carnegie Hall, I said, "I was here to do a reading for my new book. Would you like me to read a few passages?"

The first passage I read was about the protagonist's wedding, how he was faced with marrying a woman who didn't want to have a sexual relationship. When asked by his parents to retrieve his aunt from the pond where she was having an amorous encounter with one of his friends he became conflicted:

> "Why?" I asked. "Why would I want to do that? They were having a better time at my wedding than I will probably have for the rest of my life."
>
> Then my mother chimed in. "Alan, get your aunt, now; she's married!" Ten yards in waist-deep water, I moved slowly towards them in preparation for landing my aunt, hopefully giving them enough time to put back whatever they had pulled out. I trudged ever closer to Aunt Karla's

deliverance back to monogamy and was glad her husband wasn't at the wedding. My aunt's newfound playmate traded his desire for convention. So did my aunt, while my mom and dad stood quietly on shore.

Like waterlogged, lifeless puppets who had lost their amorous puppeteers, they went limp. I picked up my aunt from her watery, adulterous bed and carried her back to the banks of marriage. I sat her down on the ground by my parents' feet, and in some sort of way they pretended to help her regain her composure. (*Blueprints**)

As I read, the religious group in the back started to squirm; the musicians were laughing. The two young women on my row were wondering if there were other seats to be had in the van. After reading this, I asked if I should read another section. The two young women chimed in "Yes" along with the band members and the driver, while the back row stayed silent.

The next section I picked was the all night long home birthing of the main character's son.

The nine months went by without a conscious thought about the deeper meaning of being a father.

When Gillian went into labor, she could not figure out where she wanted to drop her celestial load. She had me, along with our midwife Beth, and Beth's young assistant to follow her from the bed to the bathroom and towards the bathtub. I filled the tub with warm water on Gillian's request. Gillian stepped into the bathtub, then wandered out of the tub into the other bedroom where she squatted on the floor and pushed for I can't remember how many hours. We coached. We realized that due to a horseback riding accident (not my fault, mind you), Gillian's coccyx bone was broken in such a way that it obstructed the vaginal canal. The four of us decided that since I was a "hands on kind of a guy," I could stick my finger into the orifice of life and re-break the coccyx bone.

I had a good grip on this root of a past primate's tail. When I started to pull I could feel the tenderness of the vascular tissue, and I got scared. What was I doing? Women die giving birth and infants meet their demise before entering this life. Is there no limit to my hubris? In this tunnel of childhood to parenthood, intrinsically longer in the males of our species, I was now confronted with accountability, even before my son entered this world, and I had to acknowledge my ignorance in so many areas. In the past, I would never have asked for help. Exiting the adult side of this tunnel, I asked this time.

"Let's call the doctor," I said. Beth concurred, conferred with the doctor we had for backup. Then, I talked to him. We all concluded that the human head at this point is soft and Gillian would try to push out the greased monkey. This otherworldly creature did fall into this earth.

In the newfound traditional birthing process, I was asked to cut the umbilical cord. I did this reluctantly, knowing that in Berrigan's life this was going to be only the first of many letting-go experiences. Next thing you know he'd be off the tit and looking for it the rest of his life, along with his umbilical cord. So be it! I got stuck with that dilemma, why shouldn't he?

I was there for the whole eleven hours, lifting a one-hundred-eighty-pound Gillian all over the place; but I was not really there, even when I had my index finger up Gillian's vaginal canal. Yes, I had escaped being touched emotionally.

Then, Berrigan grabbed my finger with his hand while still wet; I was lost, forever. Tied eternally to this earth whether I lived or died, I was now immortal in legacy. Love had swallowed my heart. It grabbed my hand and walked me to the heavens and then left me back on earth, with the feel of a bare ass landing on hard gravel.

I checked to see that the entire placenta had come out, as I know to do with horses and dogs. "It looks good to me."

I asked Beth what she thought. We agreed that it was all there, as if I really knew. I put it into a bag to throw it away when Gillian, from her vaginal expectorating stupor, moaned, "Put it in the refrigerator."

I am a sculptor and love art in general, but the contrast between the vanilla ice cream, ice cube tray with its frozen diamonds of water, and the clear plastic bag holding the blood-engorged afterbirth was just too much of a contrast for my aesthetic sensibilities. I have watched dogs roll in the carcasses of deer and cows. I've seen dogs eat their own shit and horseshit, or the hoof trimmings that are left behind after I shoe the horses of an ignorant horse owner who feeds them to their dog. (If the dog is lucky, he will vomit the hoof trimmings up; but if he is unlucky, the trimmings can get caught in his esophagus.)

The placenta was good protein. Not wanting anything to go to waste, which is my nature, I would feed it to the dogs, I thought. They took one look at it and quickly ran in the opposite direction. Did Gillian give birth to the anti-Christ? Walking over the threshold into adult male-doubt, I began questioning the ethers and the mundane. Feelings and thoughts started to collide. Now summoned to be even more accountable than even the IRS would ask, this accountability came from a deep love and feverish parental passion.

The exhaustion of Gillian's birthing Berrigan left me unready to go back to work the next day, but I had to. That weekend, Berrigan slept on my chest, his wonderful little heart beating next to mine. I did not realize then what a pleasure it was that he did not talk or understand the needs of human beings, who had their desires finely honed and developed by television-ad men and women. (*Blueprints***)

Silence filled the van. I was dropped off first at the airport.

*"Waters Parting" **"Yokes and Wings"

Love It Wasn't

I was waiting for me

Lost, taking tickets at a striptease place, The Rogue's Gallery

I thought it was because the blond dancer wore socks to bed

We flamed out

Burned out

There was hardly a wick anyway

I thought it was because the dancer wore socks to bed

I thought it was because the dancer wore white cotton socks to bed

It was just because she wanted me

My Shyness

It's not about if you are good for me. I like to look at you when you're asleep, when all your work is done, lying next to our two Great Pyrenees and one Husky. I see you in your silence. Lost in the lights, cars, bills, and boulders in this world.

When I Wasn't Shy

I love to write about women the ones I see walking
down the street wondering how they looked when
they were young or wondering how they'll look when
old or how they'd feel next to my body or how their
hands would feel in a light rain.

When Words Were My Servants

A love letter from a lean, young, freckled woman.

A thank you note for a job well done as a houseparent at
a home for children—I'd dealt with an older boy who was
beating another.

Written praise for the shoeing job that saved a horse's life; the
mare's hind hooves were lathed off while trying to kick her way
out of a horse-trailer rolling down the freeway. For a year, I
made hooves of fiberglass till her feet finally grew out.

Syllables now stab me

Messages that loved ones have died

Reports of slow sales of my bronzes and books

Friends' and families' angry adjectives pierce
 through my thin decaying skin

I grow closer to the spirit world as I move farther from this one

See Life This Way

Lost in wanting things to be different
Magic never happens when you're looking
Alone in Scotland
Found something that was missing
The woman from the Isle of Skye finds me

Alba

Wrapped in wool on the Isle of Skye

Sleep

Dreams gently touch me

Wet blowing wind

If nothing else let my bones rest

On these cliffs by the sea

Santana's Raul and Karl Drum Africa in Tacoma

fly from this old white American body.

change to African.

remember.

Lucy is my ancient mother.

we pound to the beat of her blood.

wake in her dust.

she pours me water.

brings me the taste of granite.

Other World

STEP RUNNING

MAN

Dog, four-legged friend running up the risers

In a moment of passing, win and watch him age

Heart pounding, four-legged movement on two-legged tempo

Hot meat and fire

Dogs don't care where they've been, they're not lost

DOG

Man, his life is less than mine

No fur, fang, or claw

Lives me out in safety and time

What magic does he conjure?

Why don't I live him out?

This thing called man!

So good to beat him up the risers

Gaze at soles and thighs passing me on the tread and risers

Arms cradle fur up the tread and risers in two legged beats

Are these the same steps bounded in cadence fit for gods?

Hold me and I shit, lay me down and it's my nest.

Put me down, down past the bottom step.

Clink and Luka

It was September of 1977, six months after the coyotes attacked our five dogs, two horses and goat, leaving two of our dogs and our goat dead. It was then my wife Lyra and I decided to get a big guard dog.

One newspaper ad got my attention: *Need home for a large, aggressive German shepherd. Will make excellent watchdog. Free to the right home.*

I called. A young lady with a flat tone in her voice answered, "Yes, I do have the shepherd in the paper. When would you like to see him?"

North Hollywood was a short trek from our small ranch in Angeles Crest National Forest's Little Tujunga Canyon. The door to the woman's apartment opened just a crack. On the other side were loud growls, deep barks, and an imposing sliver of a silhouette. I thought to myself, "Boy, this sounds like a lot of dog." Talking to the dog and the woman through the opening made tiny by the door's security chain, I could make out the size of the dog. He was big, at least one hundred and thirty pounds, thirty inches at the withers. He looked to be a Dane/Shepherd mix. The conversation was brief among dog, owner, and me, all of it done through the narrow space of the door.

"Come tomorrow with a toy for Clink."

"Okay."

The next day, toy in hand, I entered the small, dark, curtain-drawn, street level apartment. Clink's growl conveyed displeasure with my arrival. The woman pointed to the old couch, "Sit over there and give Clink the toy, but don't talk to him."

Clink took the yellow, rubber duck and chewed it into a dental impression faster than it could quack.

I asked this slender, pale, fair-haired woman now sitting across from me why she was giving up such a beautiful watchdog.

"Well, my boyfriend accused me of having an affair with the dog."

"Oh, I see," I said, thinking to myself that this dog is almost bigger than me, angrier than me, and is being held on a leash by a nut case. I wanted to go home. It was starting to make more sense to just shoot the damn coyotes.

Then, Clink cocked his head; something inside of him came through his big brown eyes, like, "Take me home—this woman is crazy."

I was in love. When I got up to leave, he beat me to the door, leash in his mouth, wagging his tail.

The winding canyon road to our cabin didn't make Clink carsick. He became a member of the family. Our cats, Delilah and Goldie; horses, Sparky, and Seco; and dogs, Nafka, Cotton, and Luka all liked him instantly. Clink started taking on guard duty.

This canyon where we lived was not your normal mountainous area. The inhabitants and its visitors from the city liked to dump things here, including victims of murder. The thinking was that they wouldn't be discovered. It seemed as if each year the road into our canyon would be closed due to the discovery of a body.

One of my neighbors decided that Russian wild boars would be happy in the mountains here and didn't feel the need to pen them. His boars with their piglets roamed the area. They made their way to my ranch. The young, wild hogs dug their way under our fence, ripping plants as they went. Clink fought, then killed each one. The two-hundred-and-something-pound sow tried to break through the fence. My twelve-gauge ended that.

Mike Rita and his wife Josephine also shot one of the boars as it attacked their flock of sheep. They butchered both theirs and mine. Mike and Josephine cooked them in their traditional Basque way— simply, accompanied with fresh vegetables, beans, homemade bread and red wine. In a less artful way, I cooked the overgrown piglets for the dogs and cats.

Clink was able to keep the coyotes, and it seemed everything else, at bay; there was peace again at our ranch.

A few years before, the neighbor whose wild boars had terrorized the canyon, dumped a cream-colored dog with white chest, muzzle, and paws, in front of our cabin. God only knows what kind of amalgamation of breeds he was, but he was sturdy: about sixty-five pounds and twenty-five inches at the withers. His medium length coat wouldn't take much brushing.

We named him Luka, after he had conned our dogs into pushing their bowls of food into the bushes where he hid with only his eyes peering out. Luka was the name of a man who I knew to be a wheeler-dealer.

Along with our other dogs, Luka trotted on trail rides with us, though at times he would go off the path. He would dive into the brush ahead of the horses, then burst back onto the trail, always spooking the horses. One time, he bounded out of the brush and his nose was a wee bit swollen. I jumped off of my horse Sparky to get to him. A bolt of power shot through my right arm, pulling Luka up by the scruff of neck, around in front of the saddle onto Sparky's withers as my left foot slipped into the stirrup and let Sparky go full out. We made the mile back to the ranch and into the cab of the truck in seconds. At the vet's in minutes, he was shot up with rattlesnake antivenom, saving his life. Today, almost forty years later, I wonder if I have learned my lesson, whom to rescue; whom not to?

Clink's simple kindness exemplified a deep understanding of love. The opposite was shown to me by the complex nature of Luka, who seemed to have an ulterior motive for everything, forcing me to see dogs as far more intelligent than given credit.

The next year, a one-hundred-year rain hit. Everything was either washed away or destroyed. Our water well was buried under tons of mud. We didn't own but rented these fifty-five acres and thought fixing someone else's property didn't make sense. So, six months after the flood, we packed up our belongings and moved into a semi-rural horse community, a move that I regret to this day. No longer could I let the dogs run free, ride my horse to work or into the mountains, see the stars at night, and hear myself think.

Moving to an area with no place to roam, Luka's behavior became more obvious.

Luka was a conniver from the first to the last. I overlooked his nature when we lived in the vast, remote canyon. He was a troublemaker.

Now, I was kept busy hearing complaints from neighbors about Luka: He killed chickens, chased goats, taunted other dogs, and once pissed on a good horseshoeing customer. I was paying a lot in damages.

Clink, who had constantly run the ranch's fifty-five acres, was now confined to a big yard. He was atrophying, as some big dogs do. He was aging quickly.

One day, Lyra saw Luka in action at our new house. "It was unbelievable. Luka looked straight at Cotton, Nafka, and Clink, and opened the latch. Then, in a 'let's play' stance, he motioned them to escape. I couldn't believe what I saw. Luka thought I'd gone to work. He led them into a neighbor's yard. Luka chased chickens, ducks, and teased dogs by running the neighborhood fences. Our other dogs looked on, as dumbfounded as I was. He even got Marco's pit bulls—taunting them too close to the electrified, chain link fence. He peed on them and the pits yelped with the shock, intensified with Luka's urine."

The next day, I put a padlock on the latch, thinking this would be the end of the jailbreaks. To this day, we don't know how Luka would still lead Clink, Cotton, and Nafka out of the yard and back before we'd get home from work.

On weekends, in this tame environment of horse trails, Lyra and I rode Sparky and Seco. The dogs trotted along. The hope was that I could exercise the edge off of Luka and keep Clink in the kind of condition he was in when we had the ranch. Luka would clear the yard's fence, so I added another foot to it. Unfortunately, it wasn't high enough—Luka would now jump to the top of it and pull himself over to freedom. With the fence heightened to six feet, at least Nafka, Cotton, and Clink would be safe from guilt by association. Luka was still unstoppable with his neighborhood raids. I declared no ownership of him as I tried to find him a more suitable home, like Alcatraz.

One afternoon, after living there for a month, I pulled into the driveway after work. Passing the yard, headed to the carport behind the house, I glanced at the dogs, seeing all but Clink. It didn't make sense. Of the four dogs, he would have the hardest time making it over the fence. I went into the yard and looked everywhere. He was nowhere to be found. Somehow, a wheelbarrow in the yard was moved—tipped over and apparently used by Luka as a step to liberate himself. Of course, Nafka and Cotton followed. All three were muddy.

They smelled of a neighbor's Billy goat. The stink of a male goat runs a close second to skunk.

But where was Clink?

I left the yard, and started to walk the area. I saw a clump of fur on the opposite curb of this quiet residential street. It was Clink.

I thought Clink would die in my arms someday, not alone. I'd hoped we'd share his last moments on earth. His big heart was not as strong as his soul. He died of what we believe was a heart attack. He had no broken bones or marks on him. He just seemed to have stopped in his tracks.

It's funny. Even thirty years later, he's still with me making sure things are done with kindness.

I took Luka on shoeing jobs, hoping someone would be willing to take him. Jeff Ramsey and Cindy Fulkerson were stunt people, friends, and horseshoeing customers. They were up for the challenge. What could be better? These were tough, good people. They'd be able to deal with Luka.

Sure enough, he figured a way out of their ranch to kill chickens, chase livestock and come back in time for dinner. Luka was once more in my custody.

Lyra at this time was working at a health food store. She talked up the attributes of this lovely ball of fur to one of the other employees, who took him home.

Luka's new home was in a very rough part of town. Lyra's co-worker who had taken him said, "Yeah, he stayed in the yard for a day. Now, I see him in the alley, chasing cats, begging in front of the liquor store, pissing in open doorways, napping on discarded mattresses. He's gotten fat."

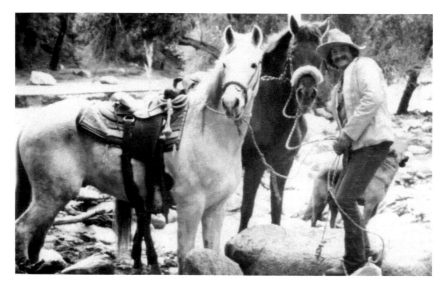

Sparky, Seco, me, and Clink

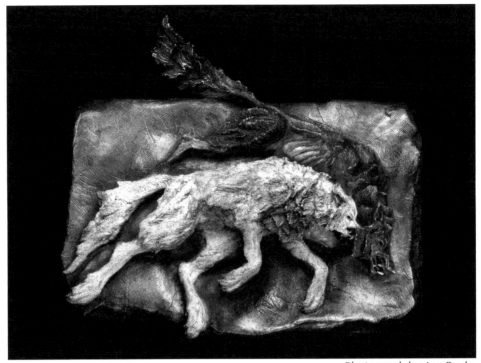

Photograph by Joe Boyle

Wolves Fighting

Bronze

Photograph by William Thompson

Fangs Woo Passion

Teeth rip

Shapes shift

Knives slash

Life in wolves' world

And mine

On the other side of youth we die

Out of the den too soon

Hunger silhouettes

Moral ground made of blood

Eat for another day

And don't look for age

It finds us

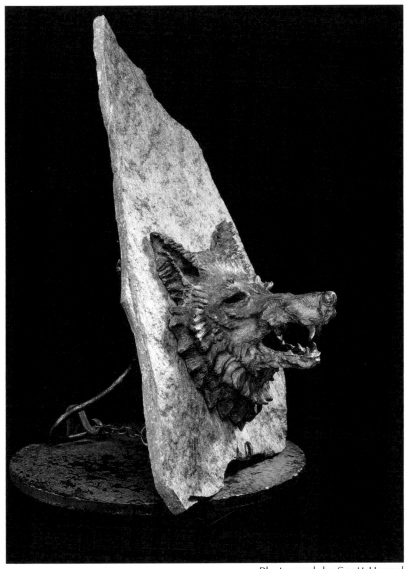

Photograph by Scott Hensel

Wolf Mask

Bronze, steel and stone

Remembering Them

Howls close and far make music around my tent. I know it's night, for even in the land of the midnight sun, evening's fur and fangs stay constant. The vigil for breeding and eating binds all shape shifters together at night. In the seven months I have lived here, never once have I gone eye to eye with one of these fellow travelers, but they are always around.

Billy, my enduring friend, is big for a Sheltie, but not for a dog. I keep him near. At five-foot-eight and 175 pounds, I spend most of my time in a rage. It's better for me to keep away from others of my kind. The sound of wolves reminds me to avoid things that could get me shot. It's easy to listen to the truth of ancient hounds. Billy was fair game, but I was not, so they hid from us. But one day by accident, I scared a wolf away from his meal. All that I saw was his big tail disappearing into the brush. His paw prints and teeth marks were the only things he left behind. The feast he abandoned was big and old, well-furred, but with ribs showing. It was a wolf, like him. He had started to gnaw on him. The dead wolf was still warm. I wanted to skin him, but he looked too familiar.

I have spent time with wolves kept by people. Part wolf or pure, their stories are as tame as their surroundings. But the wild ones, coyotes or wolves, fill my mind with thoughts of who we are and what we are becoming. I hate them and love them.

I have always been able to sense them. What happened some thirty years ago in the middle of the night will haunt me the rest of my life, and if I don't make it to heaven, it will be for a decision made on the first of those two nights.

It was raining hard in Little Tujunga Canyon. My wife and I had just upgraded from living in an 8' x 8' tent, into a 1962 Silver Streak 24-foot travel trailer. Our five dogs, Cashew, Nafka, Billy, Cotton, and Luka; cats, Goldie, and Delilah; and our goat, Pepsi, had good shelter. We all went to bed.

"Richard."

"What, Lyra?"

"Cashew wants in." Half Lab and half Australian shepherd, Cashew was strong. He did course and carouse all night long, when he had a mind to. Weather never seemed to bother him. Two years before, he trotted from Lyra's parents' house in Santa Monica to my place in the Hollywood Hills, all in one night, just to enjoy the company of Lyra's other dog, Nafka, who was in heat.

"Richard, Cashew wants in."

"He'll be fine, Lyra."

In the morning all our other animals were fine, but there was no Cashew. We looked everywhere. I searched the hills for days on my horse Sparky, looking for him. Cashew loved riding on Sparky with me. On trail rides he would run, and for every mile Sparky and I trotted, Cashew would do almost two. In the last minutes of a ride, he would run full blast and jump the fifteen and a half hands onto the part of the saddle that rested on Sparky's withers. That is where he would finish the ride. Sparky loved just about everyone. But Cashew and Sparky had a very special love for each other that I did not understand at the time. Cashew's demise had come from the call of a coyote in heat. She lured him into her pack. There and then they killed him. Lyra and I could feel Cashew's energy was gone from the property that first morning he was missing, but we could not stop hoping that we would see him. Even now, we see him in other dogs. We just look at each other; no words are uttered between us. We both know what the other is thinking.

A few weeks after Cashew's death, the movie "Star Wars" came out. Lyra wanted to see it. Closing the ranch gate after feeding and cleaning, we drove our sad hearts down the canyon road, into the city. I don't like violent movies—car crashes, gunfire, and battles. They are not what I go to movies for. Lyra and I will never agree on violent movies, although I do enjoy sitting next to her in the theater.

At midnight, Lyra opened the gate to our ranch, got back in the truck, and we drove the short distance down to the creek, where the Silver Streak was. I found our goat first. She had been ripped apart with her intestines hanging out along with her other vital organs exposed. Still breathing and looking at me with her warm brown eyes, the same eyes that would look at me as I milked her and shared the

milk with the dogs, cats, and myself, morning and night. We loved her and her joy. Billy was seventeen and blind, but he loved her most of all. They played for hours. He chased her, and when she would lose him, Pepsi would baa to him. She would stay still until Billy bumped into her. Then, the game of chasing would start again.

I took my rifle out, and shot her. And I cried. In the dark of that night, I buried her.

Before I had finished making her earthen bed, Lyra yelled, "Where's Billy?" We looked all around, called out to him for hours but saw and heard nothing. Now, with Cashew not here protecting the property, coyotes could have their way with the least defensible members of our family. I didn't realize how well he guarded us.

We never found Billy, and I haven't had goat milk since. It pains me to miss them. Now, some thirty years later, Billy's little brass bell that he wore in grizzly bear country in Alaska hangs from the outside doorway of our bedroom. If I decide to be buried, it will be in the coffin with me.

I could have bought a flock guardian dog, such as a Great Pyrenees or an Anatolian Shepherd. Instead, I built a big fence around the little cabin that was on the property, and moved the trailer near it. Our horses were big, strong and healthy. I never killed a coyote, but I did shoot in their direction a few times to scare them off. Things were safe once again. At night, the dogs, Nafka, Cotton and Luka, and cats, Delilah and Goldie, would follow me down to the corral when I fed the horses. In the cool of the night, the dogs, cats, and I sat still on the ground and listened to the sound of Sparky and Seco eating alfalfa from their feeders. The sounds of the fifty-gallon feeders had a distinctive drummer's clamor when slightly moved by the horses' noses as they ate along with nature's evening music.

Sometimes, Lyra would join me. One full moon night as we walked with our entourage of animals down to the horse's corral, we heard Sparky bellow. At the same time came the thud of his hoof hitting something alive. Seco, a 16-hand Appaloosa mare, ran around the big, open field of the corral far from her feed. In the light of the moon, Lyra and I watched three coyotes surround Sparky and take turns getting trampled and kicked.

There was no need to help Sparky as I saw my gray gelding kick a coyote into the air. Two days later, Sparky and I picked up the trail of the coyotes at the corral and followed it to the same clearing where Cashew was killed.

Up on a knoll past the clearing, I saw a coyote almost slither down deep into cover. Going back down into the wash, I circled around in back of the dense creosote and chaparral. I motioned Sparky into it, and the chase was on. We chased the coyote down the short draw to the wash, then up a small canyon with high walls and no way out.

There at the end, with nothing but steep walls on three sides of him, the coyote stood sideways to me, with tongue out and panting. I got off Sparky, picked up a large, heavy rock, and with less than seven feet between us, I raised my arm to let the rock fly. The coyote knew he was dead.

As he turned his head away from me, I saw the whole side of his jaw had been bashed in with the bottom teeth on that side drooping over like dead flowers with the bent stems of his gums still holding his now useless teeth. I was close enough now to see the dried blood of the fight two nights before splattered from his kicked-in nose and lower jaw down to his shoulder. I lowered my arm and dropped the rock. He looked at me, and I spoke to him almost in a whisper. "You'll be hunting only lizards the rest of your life."

We had other problems in the months that followed, but never again did a coyote set foot on our land.

The next winter, while driving through the Panamint Range of Death Valley in the quiet stillness of the snow, I felt them. Turning to Lyra, I said, "Over the next rise I think we'll see some coyotes." There, playing, running, and inhaling in the crisp winter, were two of them. It was there that I let go and forgave.

(Originally published in *Blueprints*)

Photograph by William Thompson

Wolf Mask

Bronze, steel and stone

119

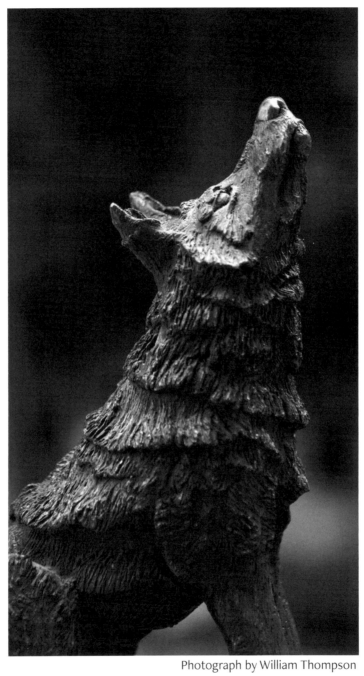

Photograph by William Thompson

Wolf Looking In Tree

Bronze

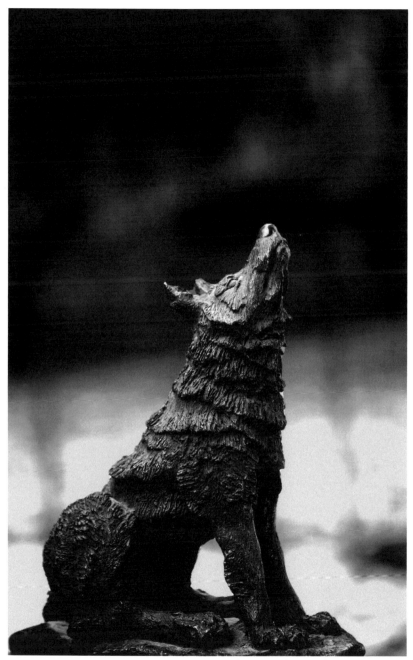

Photograph by William Thompson

Wolf Looking In Tree

Bronze

121

Clouds of passenger pigeons once darkened the skies. Then, there was only one.

In the hope of finding another, and gaining support for this last known passenger pigeon, it was named Martha, after America's first First Lady, Martha Washington.

As with so many of America's dreams, they're shot out of existence.

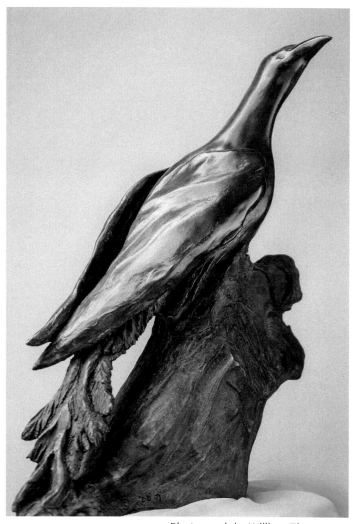

Photograph by William Thompson

Martha

Bronze

Martha, the pigeon, died of natural causes, alone in a cage at the Cincinnati Zoo on September 1, 1914, at the approximate age of 29.

Innocence Lost

Doves, Stygian wet, change to ravens.

Standing on fallen creosoted timbers dragged out from a mine

Their plumage shimmers blue-black and mirrors the sky

With wings around our dead before we knew we loved them.

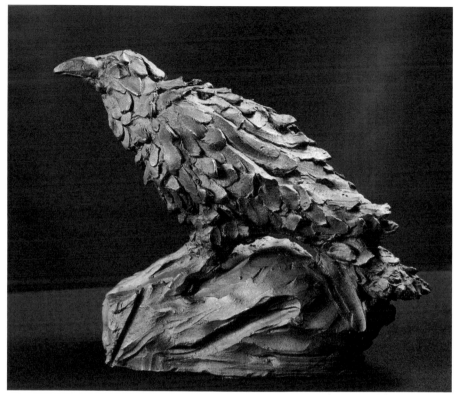

Raven

Bronze

Thief

"Hey, Dad, how come you always hide your keys inside of the camper shell? Why not just on the open tailgate?" my son Daniel asks, as he watches me hide them and pull my anvil out of the back end of the truck to shoe another horse.

"I don't know, I just do."

"You're funny, Dad," he replies, as he sits on the tailgate.

"Thanks for the compliment, Daniel."

"Well, you are."

Trying to transcend the moment— I didn't want to give my son another reason to think I wanted to be a hermit. I attempted to leave the keys on the tailgate and wondered why I was bothered, like having a sliver of steel in my finger. The image of one ranch kept coming back to me.

The ranch seemed to be on hallowed ground. Twenty pipe stalls, side-by-side, formed a half circle, a horse sheltered in each one. They'd watch me as I would shoe at least a couple of them. Sometimes, the horse at the north end of the arc of stalls would start to piss and then the rest, in order, would follow suit. Then, it was my turn.

It was here the sound and rumble of the earth came to the horses. They reared, swung around, screaming neighs, forecasting what was coming, within the safety of their stalls. I held onto my anvil stand. The earthquake was a magnitude 5.8 on the Richter scale.

This row of stalls clasped hands with a stand of enormous pine trees completing a circle. I prayed here without realizing it.

I wished for the day I'd live in the mountains where my horses' stalls would never be closed like these.

Yes, the day I was born was before my world became filled with trees, stars, abandoned mines, animals and poetry. A way of looking at life differently had been whittling me down since birth. Why couldn't I just leave my keys on the tailgate like normal people do?

Then, I remembered another day. A day a raven landed on my tailgate at this ranch. He started playing with my ring of keys while I was twenty feet away, working under a horse. The raven finally picked

up the keys, and dropped them on the tailgate a few times. In the next moment, I stood frozen, unable to believe as I watched him carry off my keys. Both bird and keys glimmered in the sun. My yelling and cursing retched out at the animal, who was now almost as high and as far as the tall pines at the end of the property.

My protests made it more real than I wanted it to be. Access to the world that I hated had been stolen.

Grizzly Bears

In Glacier Bay, Alaska, grizzlies try to rip airplanes out of the sky, eat black bears, tear open kayaks for food, and chase people out of campgrounds. Firearms are not allowed here.

I told my wife, son, and a waitress we had befriended to leave their kayaking footwear on when we went ashore, just in case we had to quickly get to the kayaks. They didn't believe me till a sub-adult brownie came out of the bush looking to join us. I distracted the young bear long enough for my party to get their footwear back on, return to the kayaks and flee the shore. It was a little bit of a standoff, but I got away before he realized that he outweighed me by four hundred pounds.

In the middle of the night, still in Glacier Bay, my wife, son, and I set up camp in a recently abandoned campground. A grizzly, two weeks prior, had ravaged it.

This was our vacation. We'd saved for the round-trip flight. Changing plans was not in our budget. Each night, I went to bed hoping the bear wouldn't be back. Our food was kept responsibly in a cache a half-mile away. We ate and cooked only at the Bay's tideland, which was also a half-mile away. My ability to smell is not good, but I smelled something while we settled in for the night.

"Lyra, do you have any food in the tent?"

"No, only this Hershey bar."

Though the midnight sun was up, I could still feel it was late at night. The trail to the cache was wide. There didn't seem to be a trace of a bear—no prints or shit. It was a success. The candy was safe. Were we?

The feeling of eating in the great outdoors seemed not to be a good idea when I discovered bear tracks at the tideland where we ate breakfast, lunch, and dinner. A mile up the trail was a five-star lodge. We decided to take all our meals at the lodge with its wealthy guests.

When it had gotten around that we were camping, that we couldn't safely eat outside, the decimal point mysteriously moved one number to the left on our dining bill—ninety percent less than it was

supposed to be. Numerous times, one of the lodge's employees had left meat on a barbeque. Because of this act, one bear in particular was now going through anything that smelled of man, including the place we camped. We found out our discount was because of this one person's irresponsible act.

Our days in Glacier Bay were beautiful, but there was always tension—the fear of confronting a bear without my having a rifle. The last day of our vacation, we kayaked to a one-hundred-foot by fifty-foot island. There were no grizzlies. I rested.

About ten years later in Misty Fjords, Alaska, sixty miles south of Ketchikan, we kayaked. Here, the grizzlies were different. They were what I was used to from living in Alaska many years before. These bears would avoid you and you'd avoid them.

My internal voice to the bear said, "My family is going to hike up this trail. Which way are you going?"

Inside of me, I'd hear a reply from the bear. "I'll go this other way. We can avoid each other."

For the seven days we were there, that is the way it was with the several encounters we had.

As we were leaving—getting picked up by a boat to head back to Ketchikan—a family with two children landed their motorboat onto the shore.

"Have you seen any bears?" the man asked.

"Yes, but they stay away. They're gentleman bears, just wanting to be left alone. They just want to live a happy life, like you and me," I replied.

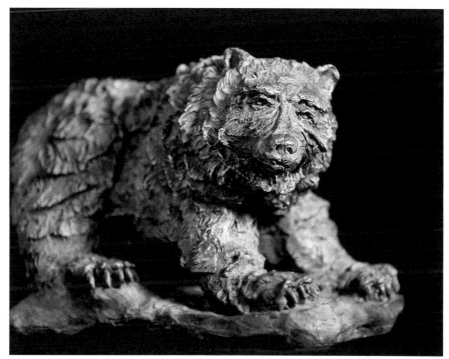

Bear

Bronze

Vulture

Death watcher

Closer to life

Wait for the dying

Take us to the other side

Clean bones to beige

Float on desert thermals

Eat while we're at peace

God's messenger isn't in silver lamé

Shower our rotting flesh with shade

Carry me to the horizon

Leave

Crooked Horns

I first learned about peace through a story read to me as a child: *How the Buffalo and The Grizzly Bear Went to War,* from the book, *Indian Tales for Little Folks.*

The bear was a bully. The buffalo avoided him till one day there was nothing to do but ram the bear off the narrow trail or fall off the steep incline himself. In this fable, from that day forward the bear never bullied anyone.

The symbolism of the buffalo has stayed with me all these years. I, at times, have been the buffalo, content to be part of something bigger than me and only tenacious in the pursuit of finding a mate. Still, at other times, I find myself angry and sullen, a loner as if linked to the heritage of Grizzly.

I remember being on a remote ranch one day, many miles west of Castaic Lake. While shoeing a sorrel gelding, that until this time had never been nervous—a wonderful horse to shoe—he started to rear and move side to side at the end of his rope. It was impossible to trim him, let alone nail his shoes on.

In the mountains on horseback, entering black bear or grizzly country, I never concerned myself with surprising a bear. A horse would always be aware of a bruin before I would. This sorrel acted as if he had seen one. I looked around the area. I glimpsed a large mound of brown fur or hair disappearing behind a hill. How could it be a grizzly? California hasn't been a home for one since the 1920s. I became scared. I was ready to un-halter the horse so he could outrun it. I'd get in my truck, try to catch and re-halter him far from harm's way. But just before I let go of the horse, the clump of brown emerged from the other side of the hill. A large buffalo appeared. It had gotten loose from another ranch. I calmly led the horse up to the barn, where I was able to finish shoeing him as the buffalo grazed below.

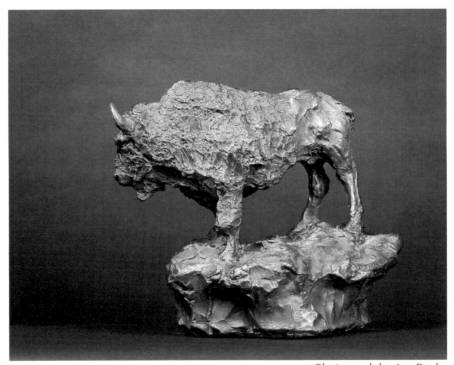

Crooked Horns

Bronze

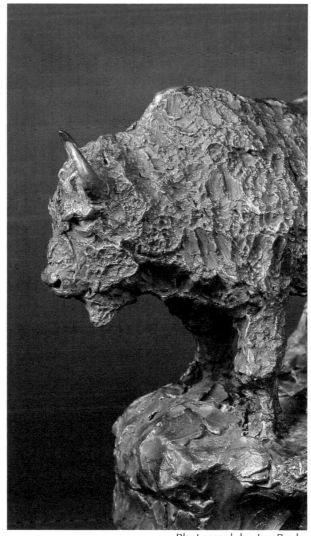

Photograph by Joe Boyle

Crooked Horns

Bronze

Snake Killer

Jack rode his mule up and down two canyons to get to my ranch so I could trim Gus's hooves. At nine hundred pounds, he wasn't the biggest mule I'd ever shod or trimmed, but the strongest pound for pound animal I had ever gotten under. I looked forward to my time with him. He would tell me when I was done. I'd trim all four hooves; then, he would pick up the left front hoof and look at me. I'd round the edges a little more with my rasp and take the hoof pick to it one more time. Gus would nuzzle me, and I would pet him again.

Today, Jack, as usual, talked while my hands and back stayed busy. It seems I listen better while working—when I have a blacksmithing or horseshoeing tool in my hand. "Richard, you're not going to believe what happened last week," Jack stated.

"You've fallen in love?" Eight weeks ago, when he was here for Gus, he told me he would love to find someone.

"No, Gus threw me."

"You're kidding?"

"No, but that's not the best part. When he dumped me, he went straight for a rattler. I didn't see it. It was right in front of us, on the edge of the trail. He stomped it, killed it before it could shake its rattles."

Gus's neck arched and chest puffed out as Jack told the story. Gus had to have the last word on everything.

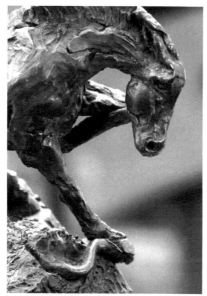

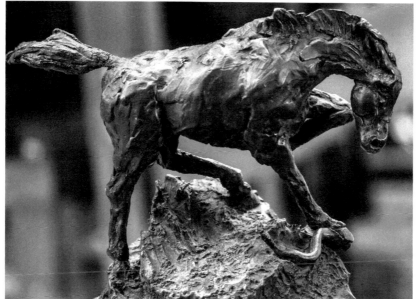

Photographs by William Thompson

Snake Killer

Bronze

Whisky

I used to teach riding to children and adults. I had a string of seventeen horses. Whisky was one of them. He was as trustworthy a horse as one could ask for. That is, when you were on his back. But when tied, he'd pull back from fright. He pulled so hard he'd break the lead rope's steel snaps.

Years later, I shod for a local police department. One of their horses, whose name was Champ, had the same intense behavior of throwing himself over backwards as Whisky did.

With these two horses, I pulled the end of a three-quarter inch, twenty-foot cotton rope through the bottom of the halter and between the front legs, and then over the withers, making a loop, secured with a bowline knot. By tying a horse this way, they're unable to pull all the way back and get hurt or hurt someone else.

A horse falling backwards is like a tree falling. A bowline knot won't tighten up on a horse even with all their power pulling on it. It worked for both horses. I did warn the head of the police department's mounted group that Champ was dangerous. When shoeing Champ, I'd move out from under him when he was about to explode. I'd just fold my arms and wait. Then, I'd ask, "Are you done now, Champ?"

Months later, one of the officers told me, "He took out two civilians and broke the collar bone and ribs of the officer riding him." I didn't ask what he meant by "took out." I didn't want a visual.

Whisky was my charge. Even though the rope through the legs and around and behind his withers worked perfectly to keep everyone safe, it was not healthy for Whisky's hind legs, his back, or his mind. I believed he'd eventually suffer physically and mentally due to fear if I didn't find a different solution. For six weeks, thirty minutes a day, I'd sack him out—feed him, handle him, gently expose him to things that caused him fear—to desensitize him, all while being tied. At the end of each day, he was fine. He'd just stand, ready to be saddled. No one had any problems cleaning his feet or brushing him after the daily act of sacking him out. But by the next morning it was as if the

calmness of the day before had never happened. I was back at square one, with no hint of progress.

I noticed he loosened up when ridden down steep slopes, had more of an even bounce to his movement. He would take to sitting on his butt as he slid down, leaving the rider in an almost horizontal saddle, like riding an elevator. He would show more confidence with each hill descended. But it never carried over to the next day.

One day after a month of this, just out of curiosity, I led him up to the top of the steep embankment behind my tack room office, then led him down the embankment and up it again. We did it three more times. Each time, he seemed more confident—happier than the time before. I finally let him loose and I remained on top of the hill. Whisky sauntered down. I watched. He trotted up on his own, went down again. From that day forward, Whisky spent his time walking up and down the embankments around the ranch, eating wild grass or standing untied next to his stall, waiting to be saddled.

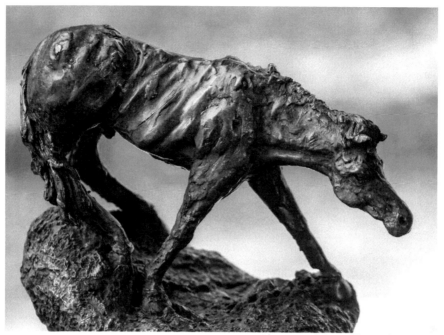

Whisky

Bronze

My Horse

I can't write his name or say it

Miss him too much

Our time together

I say his name in sculpture

A modest base of Montana bronze flagstone

His image in terracotta clay

Tail made of hot-rolled steel

Bisque-fired

Brushed-bathed in Black Raven and Red Rock hues

Glaze-fired

When you met my horse he appeared a sorrel

White socks and blaze

His true colors are obsidian

Legions of manzanita on fire

Never knew I could miss anything this much

Jimez giving Daniel his first ride with me

Caleyndar

I've met a lot of horses, have ridden the remote Baja region of Old Mexico on burros wearing the legendary mark of Christ's cross on their backs, and I've ridden the honest horses of that country while searching for internal peace.

While hiking the backcountry of California's High Sierras out of Bishop's Pass, my left arm developed an infection due to a spider bite. Out of mercy and horror at the sight of my swollen arm, the owner of a Lipizzaner stallion on the trail asked me, "Can you ride?" then dismounted and passed me the reins. Jumping over logs and rushing creeks that crisscrossed narrow switchbacks, I rode down fast, to get to the road, to get to the hospital, to save my arm. I would have lost the arm if not for the strength and sure-footedness of that splendid horse.

I have seen the honest, trembling pain of a Clyde who was a dear friend. That horse taught me more about the meaning of grace while under the fire of pain from illness than any human ever will.

To know Caleyndar is to know all great horses. How do you breed for heart?

How does one acknowledge courage from a source that does not talk of exploits to mark their bravery?

My first meeting with Caley pained me. Fifteen hands of gray-white Arabian stallion, from poll to croup: His body, even at rest, had movement and flawless symmetry. He was beautiful. Glancing down to his right front foot and maybe, out of respect, for a moment, I looked away. If only looking away would have made it not be there—but it was there. Caleyndar had a healed broken leg that could not be used without pain. I closed my mind's eye to how he injured it, the story I never want to hear.

I have shod horses since 1971, when I apprenticed with a seventh generation horseshoer. During the first seven years, I also taught horseback riding. Out of those 46 years, mostly good, I have known fine horses and honorable people. I do not know how many years Esta has owned Caleyndar, but they have been many. There are horse and rider relationships that appear to be spiritual and this is one of

them. I have stood in awe of the relationship between Esta and Caley. What words can describe a bond that is held together with no need for words? It is what we deeply feel that troubles the tongue. When thinking of how to explain their relationship, what comes to mind is a small amber light that beats to the same tempo within both of them.

Caley's pastern had gotten large and frozen hard with arthritis. The hoof had become narrow and contracted. Knowing what needed to be done to his foot, shoeing-wise, for him to be out of pain, the three of us—Esta, Caley, and I—worked to shoe him.

Caleyndar needed a larger surface area on both front feet to distribute his weight better and to start the long process of widening his right foot to increase circulation. The pain of holding his foot up was at times so great he could not stand still; he could only let me hammer one nail in at a time, then he would have to put his foot down. Never once did he get mad at me. To get the task done, I'd find myself in the most vulnerable of positions. At these moments, it would have been so easy for Caley to kick me off my feet, or to at least bite. Instead, he endured the pain and then nuzzled me after the work was done.

Years went by. For a long time, Caley was out of pain. No longer was there a need for the gentle, strong, horse-handling expertise of Esta to help shoe him, so Caley and I worked alone.

There came a time when my back was giving me some problems, but not to the point where I felt the need to rest from shoeing, or so I thought. One morning, I felt a twinge in my back while driving over to shoe Caley. After the work was finished on his feet, I stood up but then collapsed to my knees. A man who was cleaning stalls helped me get to the bench that was against the inside wall of the barn. There I sat, as this kind man put my anvil, hammers, and other tools back into my truck.

The man then went to lead Caley to his stall at the far end of the barn. Caley's visible upset over my collapse and the man's hesitance made it obvious: Caley was too big a handful for him. With the man's help, I got to my feet. Again, I started to go down with excruciating pain. In that split second, Caley put his head under my arm. He stood as still as a sculpture.

When he felt he had me safely supported, Caleyndar continued to hold me up with my feet almost off the ground. Then, he walked me back to his stall, past geldings, mares and other stallions he would have normally whinnied at. He also would have pranced high into the air with his usual animated trot. On that day, Caleyndar uttered not a sound among the equine neighborhood clamor, which echoed on both sides of us as we walked through the barn. I was his loving charge, and he walked slowly and deliberately.

At his stall, he lowered his head and I found myself on the bench by his stall. Then, Caley walked in, turned around and waited for someone to close his gate.

Photograph courtesy of Esta

Caley and Esta

Photograph courtesy of Esta

Caley and Esta

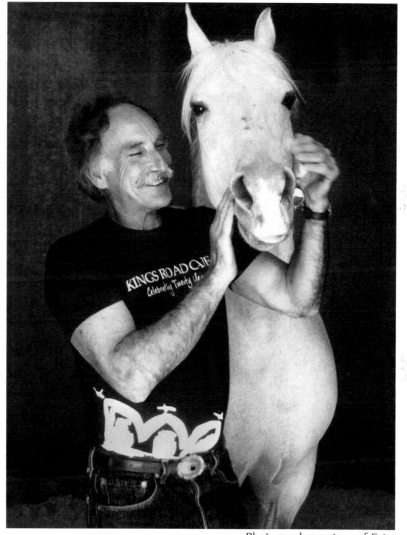

Photograph courtesy of Esta

Caley and me

Duffy

Duffy has been dead for many years. But in one sense, time hasn't moved forward since that final night. I believe it's because our relationship was as close as I'll ever come to true intimacy—not trying to say something when there's nothing to say, just sharing victorious moments, moments of defeat, and then goodbye. Perhaps we'll meet on the other side, which I now believe can happen.

Duffy towered over me, and most likely would be the tallest horse I'll ever shoe. He came to live with Maryann and Steve as a yearling. Shortly after his arrival, we met.

I was in my forties. On that day, I walked through the iron gate of Maryann and Steve's narrow driveway, toward their barn and garage area, as I'd done for many years. With Duff were Maryann, Steve, Michael Kidby, the trainer, and the veterinarian, John Thoma. Duffy was a young, beautiful Clydesdale. He made Maryann and Steve, who were both tall, look short. Even John, at 6'4", looked small next to Duffy.

I don't believe my horse-handling skills to be any better than Maryann's, Steve's, John's and certainly not Michael's, but they were silent as they watched me approach the big colt.

Those who watched Duffy's and my first encounter made comments:

"What is it with you and that horse?"

"The four of us have been trying to get him to stand still."

"For an hour!"

"And it wasn't getting any better!"

"Did you know each other in a past life?"

My making light of their comments squelched more. I was fending off my embarrassment.

Duffy hardly moved a muscle, then arched his neck so his head came close to mine. I petted his head. With the side of my thumb, I gently pushed small threads of mucus away from the corners of his eyes. I held back an emotion that came close to what I felt when I put the wedding band on my wife Lyra's hand, or when our newborn son Daniel grabbed my finger.

Without fanfare, Duffy stood like a breathing sculpture. I barely cued him—with only a light touch on his flexor tendons—to pick up his feet for me so I could trim them. I trimmed all four feet and led him back to his stall. He nuzzled my head with his nose. I petted him and told him I'd see him again in seven weeks.

Before that next time, as my thoughts sometimes do, I went to questions: What did I learn from trimming him that first time? Could I do something better on the next visit? In Duffy's case, I'd felt good about how I'd trimmed his feet. However, those comments the first time Duff and I met gave me a feeling that I might have frightened young Duffy. When I saw Maryann on my second visit, I asked her, as I petted Duffy, "Did I do something wrong last time I was here—scare this young beautiful boy? Wasn't sure about all the comments about Duff and me."

Maryann told me that it was just the opposite. She reiterated what had been said the first time and added, "It truly is that Duffy seems to know you, although I know you had never met, at least in this life."

For the first two years, Duffy did fine. His movement was strong, confident, and straight. The warmth grew between us, but I resisted understanding why there was such closeness.

As he matured, although still young, his enormous feet were not holding up to his large body. Maryann and Steve had worked him up slowly and methodically, training him to drive, to pull a carriage around the park, then to be ridden—all that ground work that novices never do. It truly separates those who own horsemanship and those who just ride. With all their efforts, his feet still were not gaining in strength at the same rate that his body was becoming massively strong. He was still a beautiful sight running free, under harness or with rider, even standing still.

Duffy's hoof trimming schedule never deviated; yet, the front hooves were chipping up and getting vertical cracks that went from the bottom of the hoof to the hair line—a clear indication the hoof quality wasn't up to the task of protecting the short pastern, coffin bone, navicular bone, and vascular system of a horse's complex foot structure. He was in trouble.

His gait became stilted. Then, hints of soreness, unlike the free, locomotive movement we all loved to watch when Duff trotted.

His hooves were very dry, though Maryann and Steve were staying away from oil-based hoof ointments which keep the foot from taking in moisture—breathing. They applied only products that had a sheep fat-lanolin base. On the coronet band or hairline above the hooves, from where the horn or fibrous tissue excretes, they used a toothbrush and massaged in Corona—a product used for everything from saddle sores to proud flesh. Supplements that were specific to hoof growth were added at each feeding.

The crazing of his front feet became, for me, a fatal threat. Duffy might fall through his hooves' crevasses deep into unbearable pain— literally standing on the raw bone of his feet.

I notched the cracks with a rasp instead of using the steel rod I had u-shaped into a tool for cauterizing cracks. He could not afford a drop of moisture steamed away from his already dry hooves by cauterizing them with this tool, red hot from my forge. The notching helped a little, but I knew that our true hope of forestalling lameness would come from putting shoes on him. With shoeing came the risk of the nail holes making more cracks in his hooves, further weakening his already compromised feet.

The hind feet were never an issue. They were sound and had no cracks. They were textbook right. So, I shod the fronts and just trimmed the hinds. Steel is steel and horseshoes made of this material will never flex as much as an unshod foot—only trimmed. The hoof expands and contracts with every step. In doing so, the flow of blood increases through it, keeping the feet thriving. As a child, the adage I learned from my Grandpa Joe was, and still is, true: "No foot, no horse!"

Now with shoes, Duffy moved even more like a beautiful loco-motive. With the slight added weight of steel, the Clydesdale's gait becomes more animated. There were times, though, that Duffy would come up sore. The next shoeing, I tested him for sole tenderness. He was tender. Once again, I would ask these feet to hold one more piece of hardware—putting pads between the shoes and his hooves,

reducing the impact and protecting the tender soles of his front feet. It made the difference. Duff moved with even more power.

But the cracks kept coming. Now I was welding large clips to the sides of the shoes. These slowed down the hooves' splitting, but not enough. With the ever-growing cracks and the tenderness of the soles, the question became how to increase foot circulation and keep him out of pain. Pain, then sickness are the products of inflammation. The only part of the hooves that didn't seem to be suffering were the frogs—a triangular shaped, rubber eraser-type substance that inhabits the center of the bottom or ground surface of the hoof. It functions as a heart for the foot. The frog works its magic in a similar way to a bellows. When the hoof is in flight, the frog expands, filling with blood. As the hoof lands and bears the weight of the horse, the blood streams out through the capillaries, taking with it the heat of muscle and hoof pounding.

One at a time, I shaped the shoes on the anvil. From thick sheets of leather, I made pads, then sandwiched them between neoprene bar wedge pads for both of the front shoes. The three components were held tightly in place with three Vise-Grips. One Vise-Grip was clamped at the toe of the shoe; the other two were clamped near the heels of the shoe. This allowed me to bore holes with the drill press through the steel, leather and neoprene all at once. Then, releasing the Vise-Grips after securing them all with four horseshoe nails, two were driven through the newly drilled holes, and the other two were driven through the third nail holes on both branches of the shoe.

Now, with the neoprene and leather secured to the shoe, I nipped the tips off the nails that were nearest the heels. But I made sure to leave enough of a nail-end to be hammered over and against the neoprene for a tight fit. Next came nipping flush the nails that emerged from the third or center nail holes. They would be pulled out in a few minutes and replaced with ones securing the corrective shoe to the hoof. The jaws of the anvil stand's vise tightly held this orthopedic sandwich as I employed the reciprocating saw to trim the neoprene and leather that extended past the perimeter of the shoes. This made for an even, clean cut.

The next step was to spread pine tar over the soles of the feet to keep the bacteria at bay. One last time, I checked the shoes to make sure they fit the hooves before nailing them on. I took the two parts of dental impression putty material and kneaded them into one. Because of the dimensions of his feet, the putty was the size of a baseball—four times the amount I'd use on a normal horse. I placed it in the middle of Duff's foot—midpoint on the frog.

Last came the shoes and pad amalgamation over the pine tar and impression material, squishing the material into form as I nailed the shoe on. The impression material would set up within a minute, so I had to work fast, nailing quickly. In essence, what I'd done is similar to what a human would do if his or her feet were severely ligament, tendon, or tissue compromised—relieve the pain with a molded, orthotic support. Later, the compound I bought at a dental supply house was replaced with a much easier to apply impression product, newly developed, specifically for horses' hooves.

Duffy was so dependent on these front shoes to fend off his pain that I could not take off both shoes at the same time, as I did with other horses.

Though it took over two hours to trim and shoe the fronts, he always stood more still for shoeing than I would for a haircut.

Though being shod this way made him sound, it reminded me of a tender living glacier waiting to split apart.

I welded still wider clips. I filled the deep cracks with epoxy and fiberglass.

Duffy, now a full-fledged adult, was handsome. His coat shone; his eyes were clear—they smiled. And I just kept filling in the ever-growing cracks with more of what amounted to surfboard material.

My heart told me he would be fine; my mind said I don't want to be on thin ice here with just Duffy, Maryann, and Steve. Maryann called in Dr. Thoma. I was relieved when I heard I was doing everything that could be done for Duff. But in my gut, I felt it wasn't enough.

The shoeing process stayed the same, and with hoof supplements prescribed by Dr. Thoma, we kept Duff's hooves in one piece.

But fiberglass and epoxy are not made for the pounding of a Clydesdale's extended trot. With the ever-widening expanse of gorges

to be filled, the fiberglass and epoxy started to crack with the normal comings and goings of a nineteen-hand horse that weighed close to two thousand pounds.

I don't remember who suggested the veterinarian, but as part of his practice, he shod horses. Again, I felt relief, this time when Dr. Jimmy Giacopuzzi drove up in his vet-shoeing truck.

Draft horses such as Clydesdales, depending on their size and the kind of specific work that needs to be done to their feet, can be far more demanding physically to shoe than a regular horse. Jimmy didn't want to shoe a huge Clydesdale without me, so we worked together. The thing that made the difference was a product he brought with him called Equithane, a two-part Urethane adhesive, contained in a two-barrel cartridge. It came with a cartridge gun and applicator tips, which mixed the two ingredients together, causing a catalytic bonding when applied. The product came in many types. The one made for foals, not the one for grown horses, did the trick. The foal formula sets up faster.

Unlike the fiberglass and resin-epoxy I was mixing in bowls, the Equithane almost instantly hardened and stood up to the pounding of Duffy's beautiful extended trot.

Along with this concoction, Jimmy brought an array of medicines to support hoof growth. Some he injected; others, Maryann and Steve gave orally. But the Equithane was the true magic.

A couple more times, Jimmy and I worked as a team. Jimmy didn't come cheap, nor should he have. I didn't want to know the total price for having Jimmy and me there together; therefore, I felt I needed to get the art of applying Equithane in such large cavities under my belt. Not only was Jimmy good at his job, he was selfless in helping me get up to speed with using the Equithane. Shortly, it became Duff, Maryann and me dealing with the shoeing.

Maryann is an artist. She drew a beautiful picture of me and lovingly signed it "Duffy", as if he were the artist. I was deeply moved by the gift, but I never really let myself completely engage with the drawing. I was too afraid to take in the entirety of this relationship between Duffy, Maryann and myself; a relationship that seems to have spanned lifetimes.

Maryann is also a horseman's horseman and was soon doing a lot of the Equithane work with me, using the cartridge gun. We injected the goo, soon to be a hoof-hard substance into the places where there should have been hoof.

As time went on, Maryann purchased her own Equithane with its hi-tech gun to use on Duffy's hooves. Maryann filled in his cracks and voids as they developed in the time between our appointments.

My dream was to alternate shoeing with just trimming—letting Duffy go barefoot. It would have been three consecutive shoeing periods, each one seven weeks in duration, then three months barefoot. Disneyland, many years ago, used a version of this schedule. The feet on their wagon-pulling Clydesdales were beautiful.

With that hope, I'd wished to put a heavier and larger shoe with no pads on Duff's front feet. I would also shoe his hinds. Larger front shoes and shoes on the hinds would have made him more balanced in the same way that hiking boots add support. In turn, he would have been even more majestic in movement. But I was already asking too much of Duff's compromised hooves. I learned to just appreciate Equithane and these three magical beings—Duffy, Maryann, and Steve.

We all age. Maryann took a picture of me at fifty-something, shoeing Duff. I had a faint bald spot at the top of my head. When Maryann handed me a copy of the photo, she apologized. I wasn't ready to be in midlife, with all that my genes have and don't have to offer. I found out I could have the photo touched up, and I did.

I couldn't do the same with Duffy's aging.

Duffy's feet, like my hair, were growing slower now. His stride was not quite as vigorous; I felt the deeper issue had never been addressed. As usual, before I could suggest to Maryann or Steve to get the vet out, Maryann had already put a call in. Because it was the feet we were dealing with, she called Jimmy. He came, but when he saw Duffy, Jimmy became quiet. His expression changed from happy to sad.

On my way to see a horse that has a problem, my mind creates a picture of what I'll do for that horse. But when I arrive, I often see something different than I'd envisioned. Sometimes, it's for the better, but at other times an unimaginable circumstance is there for me to try to untangle.

Jimmy gave Duff some sort of injection, then a supplement for Maryann to mix in with his feed. Then, he left me a compound to coat the sole with before nailing pads and shoes over it. His thinking was, "the tougher the sole, the better." As always, Jimmy did what he could, which always helped Duff and increased my knowledge. With his normal, "Let me know if you need anything!" he got into his truck and left.

In all these years of working together on Duff, Maryann had learned how to read me. I had doubts about this tar-like compound the vet left, and she knew it.

I felt there had to be something not right inside the foot, that any pressure would be bad, except for the impression material over the frog.

I feel tired even writing this. I second-guessed myself, having used this product with success before, but I felt it was the wrong thing for Duff, and it was.

In the two hours that it took to shape his two front rocker-toe shoes, cutting the leather and bar-wedge pads, nailing them on over this new heavy tar compound, the tar became unyielding and solidly fixed against the sole of the hooves, as it is designed to do. It was causing Duffy agonizing pain. Duff's eyes widened with distress. The heat of pain started to make its way through him.

Maryann and I knew that the gummy black tar, a substance that could stop a bullet, was now causing him the exploding pain of stepping on a grenade.

I pulled both shoes, started to wrestle with the Equithane and then with the rock-hard tar monsters that I'd smeared on just a short time before. For an hour, I worked at it, finally wrestling it off with my hoof-nippers. Poor Duff. I couldn't image the pain as the sweat of distress percolated up from his skin. I re-nailed the shoes with the double pads and new impression putty between the frog and pads, as usual. The three of us sighed with relief.

The next time out, Maryann said I really was the only one who understood Duffy's hooves. It made me feel good for a moment. Then, of course, I realized if I'm it, what else could I do?

For over fourteen years, Maryann and I kept Duff sound. With ever growing cracks, the formula of rocker-toe shoes, the impression material, neoprene bar-wedge pads, leather pads, and Equithane worked better than anything else we tried. So that is how I shod him.

I should have been exhausted shoeing him. Yes, I would be tired afterward, but when I'd come home, my wife would say I looked good—healthy and happy. I'd sleep well that night, knowing I had done something good for a being I truly loved.

At the age of fifteen, Duffy's life force was falling prey to the stress of something I'd always felt was looming. His cracks were growing larger. The hooves were now more Equithane than real. Equithane was a lifesaver, although it was never designed to be a total substitution for the hoof wall's gradations of thickness, breathability and the flexibility of expansion and contraction. The hoof wall works in concert with the vascular system and soft tissue—the internal part of the foot. Over many years of shoeing, I had learned to enlist my hearing into the process of shoeing. When Duff now walked, his shod hooves no longer made thundering music.

Maryann and Steve also felt something looming, though among us we'd never spoken a word of doubt until now.

Dr. John Thoma was called. He always felt that there was a hidden issue, one of circulation and something else. He now took x-rays of the front feet.

To our amazement, the lower pastern bone that partially sits within the hoof capsule had an inherited deformity, making it impossible to absorb any concussion—this small bone comes down and joins with the *os pedis* or coffin bone—the bone that rests deep inside the hoof. The coffin bone is shaped like the hoof that surrounds it.

Duff's situation was tantamount to jumping down two steps at a time with only partial ankles. Each step for Duffy depended on the foot to take up this shock, a job it was never intended to do. Because of this pastern bone's position within the hoof, the pastern bone pushed violently against the rim of the hoof capsule, likely making it the major culprit in the twelve-year fight with those cracks.

I believe if we had x-rayed him earlier it would have led us to discount Duffy's soul, and, in turn, we would have given up on him when he was a young lad.

I can't say enough for the two veterinarians—the care they exhibit with horses. I use them as a measuring tool for how doctors for humans should deal with their patients.

There was no next step. After the verdict of the x-rays, I came and shod him, as usual, working along with Maryann and Duffy; this time not much was said. There would've been more tears than words. I kept my mouth shut tightly, hoping to fend off crying. I kissed Duffy and hugged Maryann, telling her and Duff I loved them. On my way home, I cried.

Duffy was still being taken out for short walks. But how long would it be before it was wrong to do that? I don't know, and I thank God I was never asked.

On the phone, sometime later, with a crack in her voice, Maryann said, "Richard, go see Duffy. Dr. Thoma is coming to put him down the day after tomorrow."

Eleven o'clock, a Wednesday night, hours after people had left the barn, the dim light outside his stall enabled me to read a short letter tacked to Duffy's stall door. The gist of the letter was everything that could be done was done and thanking those who helped Duff. I was thanked most in that letter. My legs became weak.

In the back part of his double size stall he waited, silently standing. I walked through his stall door. He was at the other end. I was unable to go to him.

I'm not afraid of horses, even of horses I should be afraid of. I had never felt a minute of fear in all the years of shoeing him, but that night I was scared. My arms were frozen in the warm night. I couldn't move. In all of Duff's discomfort, he walked to me, lowered his head, pressed his nose against my chest. I apologized for not being able to do more. My words were only good for giving me permission to cry. We both quietly stood. Duffy's size and shape were different—smaller, but larger in the sense that he was no longer a horse to me. He was a being beyond the physical. For the first time, I really saw who Duffy was. He was pure goodness.

We stood there for two hours. He didn't let me leave. I didn't resist.

It's taken me a long time to be able to tell this story, and a long time to look at the rendering that Maryann drew of me.

Though anyone can tell it is a picture of me, I see it's not totally an image of me—a smiling man, wearing a heavy sweater, eagle above, with wings surrounding my head as if we were on the same journey of flight. There is more: The image I see almost frightens me. It's a beautiful image of something that is the likeness of a man, but every curve and shadow is that of an animal, hinting at fur and animal muscle. Beyond that is the essence of what I saw in Duffy our last time together in this world—his soul. And I remember Maryann's signature is not at the bottom corner. Instead is a small picture of Duffy and his name.

Photograph by Maryann Jorgenson

Duffy and Me

Sketch of me by Duffy via Maryann Jorgenson

Both Worlds

Too Late to Draw Back

In a gale the chairlift I ride swings edge to edge

Cliff rocks stay solid as we glide by.

In this wall of stone, a crack grows,

An unknown flower blooms.

If I Tend Myself

my family, friends, animals, plants

my strangers with silent compassion

I understand this life

If Only

mending of lame horses' feet, sculpting the feminine,
or a poetic line brought me closer to love,
I'd be less a fool.

I gather praise for my sculptures and shoeing;
then betrayal built on a young veterinarian's ignorance of
how leather pads should look between hooves and shoes after
eight weeks of riding.

I learned young to mime self-hate so no one
could hit me harder than I would, until I almost believed it.

Revolving thoughts at night grow into dragons, burning and
slashing one another.

In the morning, I wonder why I'm still here.

Today, for the first time in a long time, the war is won
by the forest-green scaled, fire-breathing dragon who
purifies the sky.

He watches and waits for me to say—and I do—
"It's time to tell the world that brutality will no longer
be tolerated."

Method of Disorder

hot-rolled steel, hammered

stone, cut into form

later

I start all over again

work eight hours

I discard

numbers two and three

number one first one discarded

is now sadly perfect to hold some fossilized tusk

I weld bolts to prongs that cradle tusk

cut three more stone bases finally

a faultless shape with the chip in the right place

Then the patron asks, "Did you mean to have a chip
in the stone?"

I say, "Yes."

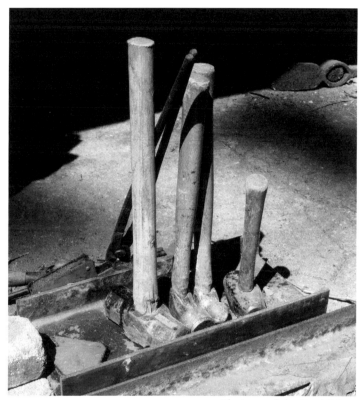

Photograph by Fred Prinz

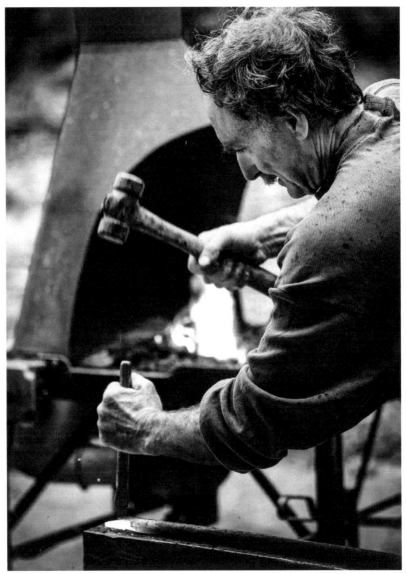

Photograph by William Thompson

The Fourth Season: 2016

When I ditched the second grade and most of the grades after, I was changing the world.

I was not going to go along with The Program.

In my twenties, I saw my dreams coming true: a ranch and a simple life. It was handed to me then. I just didn't know it. I did not know that my newly bought 1973 Dodge Power Wagon horseshoeing truck's immediate obsolescence was a tremendous gift as its drive train came apart. With no reliable way to carry a thousand pounds of tools and horseshoes, I needed another way to make money. The work I found was teaching horseback riding to kids who came from troubled families. There, I met another member of the staff, who later became my wife. If the me, now in my sixties, could have told the me in my twenties, *develop your equestrian teaching skills and somewhere down the road have a teaching facility of your own in a beautiful place*, I wouldn't be writing this today.

The education I'd sworn off when I was seven was now exhuming itself from the grave, telling me to just do what convention dictated. Or what I thought so-called better men wanted from me. So, after seven years of teaching riding, I went back to the more lucrative profession of shoeing horses. My new bride wanted to follow a path in a business that was not in my plans. I believe that when you are in a partnership of love, share the journey. As an anthropologist, Lyra has studied natural, native, and for the lack of a better term, alternative medicine. This has been her life's work. So, soon after our marriage over forty years ago, she joined forces to start a natural supplement company with a conman dressed in a business suit. He had all the mannerisms of the coiffed and assured entrepreneur. He needed investors. I gave him my ranch money, hoping this would be a good thing.

Like a plow horse driven by the carrot and stick, my wife held on for thirty years. For the last few of those years, in her futile attempt to avoid the stick, we moved to the Washington branch of the company.

Finally, we got a third of what was promised, twenty years late.

Though the dream of a ranch has dimmed after 30 years, it is still there.

This week, I fly from our Seattle home, since 2008, down to the studio of our home in Los Angeles to assess what to take back to Seattle.

I'll then fly back to Seattle. My wife and I will drive down in the truck, retrieving all of those tools and items of hardware that were left in safekeeping with our renters. The selling of the L.A. house will give us the money needed to buy the ranch.

I'm terrified to go back into this house I rebuilt, which kept us warm and safe, that we mortgaged time and again to pay for college loans, my son's life-saving surgery, new shoeing trucks and vacations.

She is as much a family member as I am. How can I sell her? But I have to. It is the beginning of my coldest season. She needs a new family to raise. It's not that I haven't given to her. I gave her strong walls, a modern vascular system of electricity, water, and cured her old bowels. I've showed reverence for her beauty and her past through my works of blacksmithing: gates, hinges, handles, towel racks, a solid copper shower curtain rod that brings two shower curtains into an overlap so no shower spray escapes. I've hung over twenty-five feet in the air with grinders giving character to her rafters. In the middle of the night, I made a cowling over her stove, framed with two by fours, wire, tarpaper, and bathed these bones in mortar. I strung handfuls of small tiles around the cowl while the mortar was still wet. You can stand at the kitchen's sink and look up through the kitchen's wrought iron grate, past the third-story master suite's skylight to see Elysian Fields.

My loving wife has found an arborist to show the new owners how to care for the two redwoods. The trees stand guard on either side of the home's twenty-five foot, multi-paned, 1923 picture window.

There is no other house like this one. Yes, there were blueprints and permits, but the plans were never copied for another house. We learn what a house is by the hands that built it. I am not in the business of building homes. My work is as a sculptor, blacksmith, farrier, poet and storyteller. I'd hoped the new owners of my house would have

come to me, shared what they loved about the house and asked me—this older man—what they need to understand.

What I would have told them:

There is something alive in everything. Do not disturb the Tennessee pine floor, subfloor and floor joists that gently blanket the ground to construct an unnecessary crawl space called for by one of the many inspectors you hired, who was looking for a buck.

I'd have told the buyers:

Although much of her is new, her heart is old.

We know the sun came up today. We know that a journeyman carpenter, a talented architect, a qualified inspector, and the owner—an artisan—worked long and hard on this house.

What we don't know is if there will be a tomorrow.

What we do know is my house has protected all those who have slept under her roof.

I hope and pray you will find comfort here.

Bless you both.

Instead, they tried to shame her with fourteen inspectors finding fault with her age.

My wife and our hard-working realtors believe I respond first from my emotions and then, after a long period, I become objective: "It's only wood, cement..." Well, that's bullshit. It was passion that over twenty years ago brought me to save our home from being destroyed by a fledgling contractor. I had to fire him three times before my wife and our architect would stop rehiring him.

It was the hope that my wife would love me the way I loved her that kept me working on our home all night long, after shoeing horses all day. Love motivates me.

I believe there is no such thing as a lesser thing.

Front Gate to 8253

Photograph by Fred Prinz

Studio door

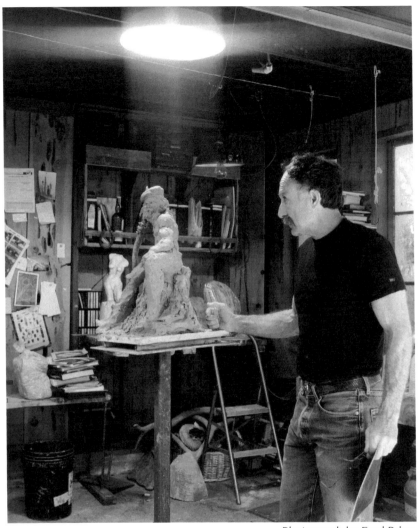

Photograph by Fred Prinz

Lookout Mountain Studio

Photograph by Fred Prinz

Living room

Towel rack made from a bar of 1″ x 1″ hot-rolled steel
in the forge and on the anvil

One of twelve forged and grinded
staircase banister brackets

Photographs by Fred Prinz

Photograph by Fred Prinz

Staircase banister, welded and forged

Whole

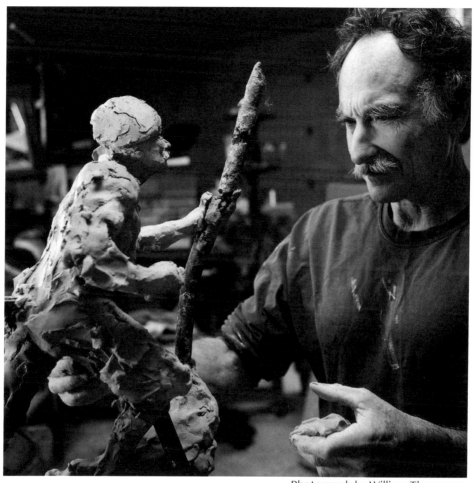

Photograph by William Thompson

185

The Blue Marble

A wounded stag bellows.

A universe swirls,

collecting stardust.

It's My 62nd Year

I sit in the five-thousand-acre park of my childhood. I dreamed my dreams here in Griffith Park. A life I'd have in the mountains, horses I would own, the woman who would be my true love. It was here I met Paul, a man in his fifties who had trained dogs for the military, was an artist, a stevedore, Shakespearian actor, and heavy weight boxer. He studied for the priesthood, but was told he liked women too much. He mentored me in the ways of the artist's eye: how to observe nature—enjoy it—and how to understand dogs.

In this wildness, actors taught me how to read as I helped them rehearse their lines. My life from seven to fourteen was full in this patch of wilderness. Here, an older woman, a poet with beautiful legs, took me home with her, tutored me on my maleness. I recognized the woman I ached for because of the lessons learned among these sycamore trees. Every wish made in this glen comes true. I've had horses that loved me and I them, friends that I've cared for and them for me, but yet I never seemed to completely grasp what was given. I now grasp memories, talk to the dead, and fall asleep with everything I thought I'd discarded.

Evening

Branches fold around the tree looking for sun

I follow

Dream, in the most elbow bent way

Fall prey to all

Loosen the light

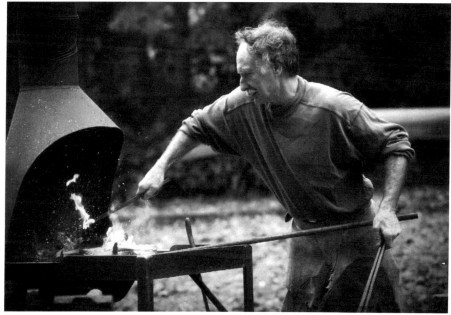

Photograph by William Thompson

Photograph by William Thompson

Richard A Heller is the author of *Blueprints*, a modern-day story of the Greek God Hephaestus—a search for belonging.

The story *Caleyndar* was originally published in *The Arabian Spirit*.

website: <u>richardaheller.com</u>